THE ART OF MIGRATION

PAINTINGS BY **Peggy Macnamara**

TEXT BY **John Bates and James H. Boone**

WITH A FOREWORD BY **John W. Fitzpatrick**

THE ART OF

MIGRATION

BIRDS, INSECTS, AND THE
CHANGING SEASONS IN CHICAGOLAND

THE UNIVERSITY OF CHICAGO PRESS

CHICAGO AND LONDON

PEGGY MACNAMARA is artist-in-residence at
the Field Museum of Natural History, Chicago,
and also associate professor at the School of the
Art Institute of Chicago. She is the author of
Illinois Insects and Spiders and *Architecture by Birds
and Insects*, also published by the University of
Chicago Press.

The University of Chicago Press, Chicago 60637
The University of Chicago Press, Ltd., London
© 2013 by The University of Chicago
All rights reserved. Published 2013.
Printed in Canada

22 21 20 19 18 17 16 15 14 13 1 2 3 4 5

ISBN-13: 978-0-226-04629-7 (cloth)
ISBN-13: 978-0-226-04632-7 (e-book)

This paper meets the requirements of
ANSI / NISO Z39.48-1992 (Permanence of Paper).

Library of Congress Cataloging-in-Publication Data

Macnamara, Peggy, artist, author.
The art of migration : birds, insects, and the changing seasons in Chicagoland /
paintings by Peggy Macnamara ; text by John Bates and James H. Boone ; with a
foreword by John W. Fitzpatrick.
 pages cm
Includes bibliographical references.
ISBN 978-0-226-04629-7 (cloth : alkaline paper) —ISBN 978-0-226-04632-7 (e-book)
1. Birds—Illinois—Chicago Metropolitan Area—Pictorial Works.
2. Birds—Migration—Pictorial Works.
3. Insects—Illinois—Chicago Metropolitan Area—Pictorial Works.
4. Insects—Migration—Pictorial works. I. Bates, John, 1951– author. II. Boone,
James H., author. III. Fitzpatrick, John W., writer of added commentary. IV. Title.
QL674.M293 2013
598.159'80977311—dc23 2012048316

DEDICATION
to Dave Willard

I dedicate this book to Dave Willard. There are many reasons for this dedication, not the least of which is his devotion to the Field Museum for over thirty years as collection manager before his retirement in 2010 and his willingness to share the wonders of the third-floor, behind-the-scenes collection areas with hundreds of visitors each year. Each visitor got a bit of Dave's expertise and took away an excitement and knowledge about birds that he or she didn't have before.

Dave's interest in birds began as a child of six or seven on his family farm in Wisconsin. One fall, he observed a variety of birds feasting on some fermenting apples. Although his mother and aunt could identify birds and had given him a beginning in ornithology, he had not really experienced birds. On this day, watching Baltimore Orioles, Scarlet Tanagers, Rose-breasted Grosbeaks, and Indigo Buntings up close hooked him for life. Ini-

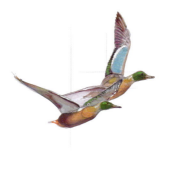

tially interested in butterflies, he now turned to birds. Even today, Dave recalls this experience, saying, "I still love seeing Rose-breasted Grosbeaks," and he gets a kick out of "seeing how many [species he] can see in a day."

In the fall of 1978, Bill Beecher (then director of the Chicago Academy of Sciences) suggested that Dave check out McCormick Place in the morning because birds often hit the building as they migrate along the lakefront. So Dave stopped by McCormick Place on the way to the Field Museum to investigate the site and found a few dead birds. From this day forward, the gathering of migration data (from collecting casualties) has become a continuous, organized study that has involved Field Museum staff and many volunteers. Dave, Mary Hennen, and Doug Stotz have taken turns collecting from this location. Volunteers check many other buildings in the city each morning during migration as part of an organized group now called the Chicago Bird Collision Monitors. Dead birds are collected and brought to the Field Museum; their data is recorded in the migration ledger. Through the years Dave has recorded a number of rare birds, such as Painted Buntings and Cave Swallows, and through gathering data and preparing specimens of these casualties, he has assembled a detailed three-decade picture of the migration of birds through the Chicago region, with some surprising findings. For example, recovered specimens of American Woodcocks include females already

carrying eggs, indicating they had mated along the migratory route before arriving at their actual breeding grounds—information that was previously unknown.

This thirty-year survey has also resulted in changes benefiting birds. For instance, buildings with a tropical garden in the lobby attract birds; birds hit the glass trying to get in to what might be a place to feed or rest. Data show that more birds die when inside lights are left on overnight and in buildings with large expanses of external glass. Over the years, managers of many buildings agreed to turn off their lights whenever possible, and now only a quarter as many birds are being found dead at these buildings—dropping from two thousand to five hundred birds a year at McCormick Place alone. This effort, known as Lights Out Chicago, was spearheaded by Judy Pollack and the Audubon Society. Now the program is a cooperative effort between the city of Chicago, the Building Owners and Managers Association of Chicago, Audubon, the Chicago Bird Collision Monitors, and the Field Museum.

This only begins to describe the many contributions Dave Willard has made to the Field Museum, to the world of ornithology, and to the many people touched by his tireless devotion to birds. For this and for the ways he has enriched my work, I dedicate this book to him.

{ PEGGY MACNAMARA }

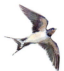

FOREWORD

by John W. Fitzpatrick

Louis Agassiz Fuertes Director,
Cornell Lab of Ornithology,
Ithaca, NY

Since the first time I ever saw a Peggy Macnamara painting, I have been utterly enchanted—both by her technical brilliance and by her ethereal vision. Whether capturing stationary mounts behind reflective museum glass, or migrating gulls in the wind along an icy Chicago lakefront, Peggy is constantly experimenting with form, color, and juxtaposition. Her paintings—even her most perfectly classical ones—strike me more as expressions of wonder than as illustrations of nature. She has an amazing ability to dissolve scientific realism and honest draftsmanship into layers of dreamlike fantasy and colorful hallucination, yet every painting clearly expresses appreciation and abiding love for the intricate shapes, structures, and motions of the living world.

In this wonderful book, Peggy celebrates nature's magical gifts of wings, flight, color, and song that appear and disappear with the turning of the seasons along the central flyway and the greater Chicago region.

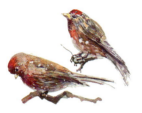

She reminds us that birds are not the only dazzling seasonal migrants, as many insects also take part—from the amazing annual cycle of monarch butterflies to the massive movements of dragonflies, such as green darners and black saddlebags. Peggy throws herself into the challenge of capturing the now-you-see-it-now-it's-gone motion of flying insects, but equally bravely uses spread-wing specimens of butterflies and dragonflies in her colorful, multilayered compositions of birds. "Routes of Some Migratory Birds and Insects" (plate I), like many of her works, is a dazzling and poetic interplay between hard science and striking composition. Migratory pathways and seasonal plumage changes are cleverly expressed as ephemeral sketches, with brilliant focal points interposed against hemispheric shades of greens, yellows, blues, and purples to create both an intellectual and a visual feast.

What I respect most about Peggy's watercolors is that each one is ruthlessly honest, bold, joyful, and unafraid. Her compositions, and her contrasts of light, shade, and color, are strikingly well conceived, yet her brush strokes are minimal and seem effortlessly, almost casually applied. Everything still looks wet inside a Peggy Macnamara watercolor. Its vivid, sometimes even surprising colors play off one another almost as if purposely exaggerated to celebrate our human senses and passions.

It is absolutely perfect that this book is dedicated to Peggy's colleague at the Field Museum, Dave Willard, who has been a dear friend and field companion of mine since the mid-1970s. Via this book Peggy joyfully honors all four seasons and the panoply of natural splendors constituting the Upper Midwest, just as Dave has honored them his entire life. Her numerous images from the Chicago lakefront and the Field Museum's bird collection (yes, including study skins and even piles of dead birds) take us to places both indoors and out that Dave probably knows better than anyone else alive today. Everyone who knows Dave appreciates his unusual kindness, integrity, and human caring. His gentle external character makes all the more powerful his fiercely burning passions for birds, nature, and the future of natural systems all over the world.

Migration is one of the most remarkable of all biological spectacles, and humans are privileged to be able to appreciate it at both local and

global scales. Even in the woods around Chicago, birds, butterflies, and dragonflies remind us that earth's natural systems flow via grand, dynamic corridors and without borders. Hats off to Peggy Macnamara for creating such a brilliant celebration of this flow.

INTRODUCTION

by Peggy Macnamara

Several years ago, I was standing at the north door to the Field Museum talking to Tom Schulenburg, an ornithologist then with the Field Museum, about this project. It was a beautiful fall day and he offered to show me a "bit of migration." We walked out from the main entrance to the terrace, which is about half a story above the ground. This enabled Tom to lean his head under the canopy of a ground-level crab apple tree. As we both stood very still, he began making bird sounds, and vireos seemed to appear out of nowhere. For those tuned in to urban nature, there are countless such migratory "close encounters."

In the fall of 2007, I sat in my car at a light at Randolph and Peoria in Chicago watching a lone monarch head west. That moment, which I can still visualize, inspired me to visit Mariposa Monarca Biosphere Reserve in the Mexican state of Michoacán in January 2008. A short hike brought

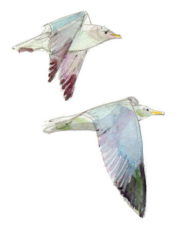

me to a place in the hills that is home to millions of wintering monarchs. Tree branches were so heavy with clinging butterflies that they bent almost to the ground.

One of the best migration stories is that of a Brown Creeper, a species listed as threatened in Illinois, which was found on April 17, 2008. The bird, which had hit a building in downtown Chicago, was found by Laura Muraoka and brought to the Willowbrook Wildlife Center in Glen Ellyn. Here it was banded and released on the same day. On April 17, 2009, one year to the day, it was found two blocks from the original site. Although it had died, it is an example of the precision and mystery of migration.

On December 10, 2009, hurrying to my car in frigid temperatures, I heard a strange sound, different from the loud bursts of Canada Geese. I looked up to see the soft, curving lines of hundreds of Sandhill Cranes.

The warm northern November had slowed their departure, but now they were moving south in large waves. Conservation ecologist Doug Stotz, who stepped outside the museum to watch, counted more than seven hundred cranes at midday. And recently I saw a Ruby-throated Hummingbird near the Shedd Aquarium, taking a respite on its long journey to Costa Rica. I figure if that tiny bird can make it to Central America each year, I can learn how and why it makes that journey.

Chicago lies along a bird migratory route called the Mississippi Flyway, which runs along the edge of Lake Superior to Lake Michigan and along the rivers that flow into the Mississippi. Insects, too, migrate through our area. But for many midwesterners, bird and insect migrations go unnoticed, and the work of those who study these migrants occurs "behind the scenes." With *The Art of Migration* I hope to give you a glimpse into the magic of the migration of birds and insects along the Mississippi Flyway. I don't propose to give you the complete story; this is better done by the experts. I only hope to pique your interest with some visuals so as to encourage further exploration into the science of the subject. There are many wonderful references for specific and detailed science of the birds and insects that pass through and live along the Mississippi Flyway and in the Chicago region. Some of these books are listed in the "Further Reading" section at the end of the book.

While outside the Field Museum lies the magic of seasonal movements of birds and insects, inside the museum are people studying this and other phenomena. Dave Willard, collection manager emeritus and adjunct curator in the Division of Birds, has kept a thirty-year ledger of migrating birds killed by hitting local buildings. Likewise, down the hall in the Division of Insects, scientists and volunteers sort, identify, and study the tiniest migrants. All this information contributes to our knowledge about the biology of these species.

Just as leaning under the crab apple tree during bird migration proved to be a fantastic experience, so does a trip to the Field Museum's third floor. Anyone visiting these nonpublic areas comes away giddy and awestruck with the diversity and wonder of nature, as well as by the dedication of the scientists and staff. It is the purpose of this book to bring "behind the scenes" into the light and focus on the science and wonder of migration from an artist's point of view. The better we understand what this natural world is about, the more we can appreciate and enjoy it.

This book was a collaboration, and besides the amazing work by the two main contributors, John Bates and James Boone, I would like to thank everyone else involved. I arranged bird plates with Dave Willard. Bob Andrini contributed thoughts on the seasons' introductions. Lisa Hung and Gretchen Wilbrandt assisted with editing insect text, as well

as providing facts on insects along with Jim Louderman. Arlene Kozoil contributed wonderful photos of birds migrating. Mary Hennen and Tom Gnoske supplied bird specimens to paint. Doug Stotz contributed his expertise and experience as a scientist and conservationist. Paul Lane photographed each plate and then patiently corrected and reshot a good percentage of them. And behind the scenes Francie Muraski-Stotz, Barbara Becker, and Laura Nelson wrote and edited all the ever-evolving material and transformed it into a readable text. And finally I would like to thank my children, who have migrated to three different countries and keep me feeling very blessed.

A Note on Common Names

In referring to common names of birds and insects within the text, we followed standards set by the professional associations for each group. For insect names used in the text, the first letters are lowercased (e.g., obscure sphinx moth), as specified by the Entomological Society of America (http://www.entsoc.org/pubs/common_names). For bird names used in the text, the first letters are capitalized (e.g., Indigo Bunting), as specified by the American Ornithologist's Union Checklist (http://www.aou.org/checklist/north/).

PLATES

ARTIST'S NOTE: *Late in the process of making the plates for the migration project, I began to paint from photographs taken by Arlene Kozoil. It seemed to be the only way to capture birds in flight and their movements. As I finished each of these new compositions, I noticed that the birds' natural choreography adhered to one or more of John Ruskin's nine laws of composition. In his book The Elements of Drawing, Ruskin, a nineteenth-century artist and theorist, used still examples, like leaves, to demonstrate his compositional theories. And although the birds arranged themselves in these ways to save energy, they composed themselves in balanced and beautiful ways that illustrated Ruskin's laws.*

COVER PLATE

The V-Formation SANDHILL CRANES

Sandhill Crane

Order Gruiformes, family Gruidae, *Grus canadensis*

As early as March and as late as December, even urban dwellers may hear the far-carrying, gurgling cries of Sandhill Cranes and spot their V-shaped flight formations high overhead as the birds migrate through to their breeding or wintering grounds. Perhaps as you watch, the lead bird slips back, letting another bird go to the front of the formation. For many people this flight configuration—also used by ducks and geese—marks the arrival of fall. Scientists think the V-pattern might give all but the lead bird an energetic lift; as the lead bird slips back, it can take a rest. The exact shape of the V-formation might vary depending on how closely related the individual birds are and how much the lead bird is willing to sacrifice for the rest of the group.

Sandhill Cranes have a wingspan up to eight feet across. They migrate during the day, taking a lift on a thermal sometimes up to several thousand feet, then gliding on to the next thermal. On good days, Sandhills can travel up to five hundred miles by this method.

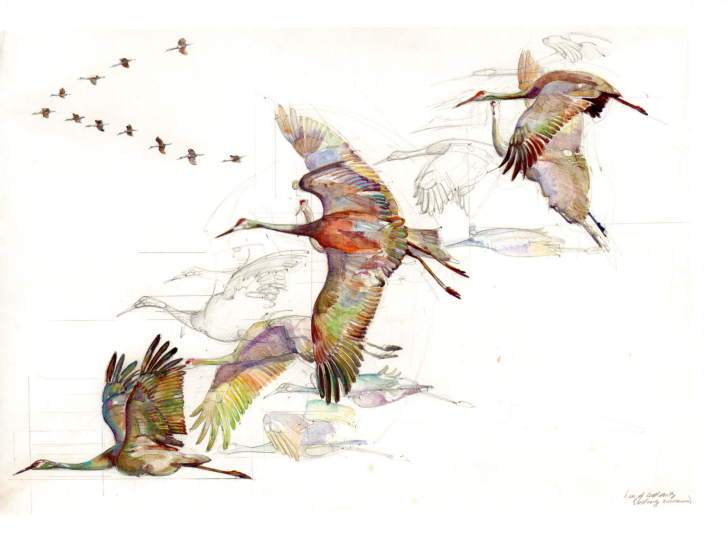

law of continuity
(underlying succession)

MIGRATION

and Other Strategies to Survive the Seasons

Migration is sexy. The notion of a tiny humming-bird or delicate butterfly traveling hundreds of miles is both captivating and awe inspiring. Migration is a highly observable, compelling phenomenon, but it is just one among many strategies that animal species use to deal with seasonal change. So while this book is called *The Art of Migration*, it's about more than that; it offers a glimpse of some of the species found in the Chicago area in different seasons and the adaptations and strategies each has evolved in order to survive.

Insects and birds have essentially two ways of deal-ing with northern winters: stay and try to survive, or travel to a warmer place that has more food. Species that stay must be able to endure subfreezing tem-peratures and deal with a scarcity of food. Those that leave, or migrate, face the challenges of surviving a long, grueling journey.

Birds display a wide range of variation in migra-tory behavior. Around Chicago, "summer residents," such as Chimney Swifts and Scarlet Tanagers, are spe-cies that migrate here in spring, breed here in summer,

and migrate south in fall to wintering grounds. For "winter residents," such as juncos and tree sparrows, Chicago is their wintering ground; in autumn, they migrate into the area from breeding territories farther north. "Passage migrants" are those that neither breed nor winter here but migrate through en route between breeding and wintering grounds. This group includes many shorebirds, such as Least Sandpipers, Sanderlings, and Ruddy Turnstones. Other species, including Northern Cardinals and Black-capped Chickadees, are "permanent residents"; some members of the species are here year-round, although individuals continue to move around locally. Chicago also hosts varying numbers of "irruptive species" like Pine Siskins and "facultatively migrant" species like Snowy Owls—birds that occasionally migrate in due to scarcity of food or colder weather in their usual wintering territories.

For insects that migrate, the story is somewhat different than that of birds. Because adult insects have very short life spans, a single individual often can't make the entire round-trip. Those that migrate south will reproduce, and their offspring and subsequent generations will continue the migratory journey. The migrations of some insects, such as monarch butterflies, may cover thousands of miles. However, most insects don't migrate. They become less active when freezing temperatures arrive and survive—as eggs, larvae, nymphs, pupae, or adults—finding ways to avoid freezing, including even altering their body chemistry to make an "antifreeze" that keeps them frost-free.

For both birds and insects, the strategies to survive the seasons are as diverse as the species themselves. This book covers only a sampling of species in the Chicago region, but those featured offer a tantalizing look at the amazing stories of survival that take place quietly in our own backyards, season after season.

ARTIST'S NOTE: *Figure-ground is the relationship of your subject to its surroundings, and balancing both is a challenge to most artists. The figure and still life images always steal the show. Wildlife painters can add habitat and expand the information presented. Here I welcome the use of the map to give an interesting ground as well as to give the whole composition structure.*

PLATE I

Routes of Some Migratory Birds and Insects

The Great Lakes are both a draw and a serious obstacle for migrants. Birds and insects use the coasts and the great rivers flowing in and out as visual markers for their journeys. The water and shorelines provide airways for north-south flight and places to rest and find food for the next stages of a journey. At the same time, birds and insects blown out over the lakes in bad weather must struggle to reach the shores.

The Chicago area itself is a critical migratory stopover and an exceptional place to view the pageant of migration. Parks, beaches, and dunes stretch along the lakefront; their trees, shrubs, and native plants offering food and resting spots for exhausted birds and insects. Farther inland, city neighborhoods, suburbs, and industrial areas are scattered with parks, ponds, forest preserves, and rivers; wetlands survive even

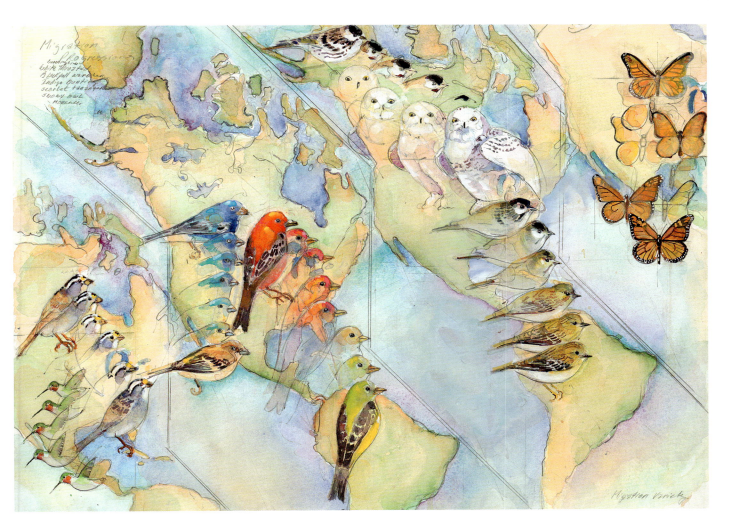

Migration
Progressions
bunting (?)
White throated
blackpoll warbler
Indigo bunting
scarlet tanager
snowy owl
monarch

Migration Variety

among the steel mills and ports of southern Chicago. In contrast, open farmlands west of the city offer fewer resources. Throughout the year, millions of birds of more than three hundred species pass through or live in the Chicago region.

This map illustrates the routes of migration in our area for some typical birds and insects. For information about the best places to find them, see "Watching Birds and Insects in Chicago" at the end of this book.

FROM LEFT TO RIGHT:

Ruby-throated Hummingbirds fly nonstop across the Gulf of Mexico to winter in Central America.

White-throated Sparrows breed just north of our area and into Canada and return to the southeastern United States to winter.

Indigo Buntings winter in Mexico and Central America and fly north to breed across the eastern United States, including Illinois.

Scarlet Tanagers breed in eastern North America (including around Chicago) and fly to South America's Amazon Basin for the winter.

Snowy Owls breed in the tundra of Alaska and Canada and occasionally come as far south as Chicago in winter.

Blackpoll Warblers breed in Alaska and northern Canada, and migrate to the East Coast and fly nonstop across the ocean to reach South America and the Amazon Basin to winter.

Monarchs breed in North America in the spring and summer. Populations east of the Rocky Mountains fly south to overwinter in Mexico. Monarchs west of the Rockies fly southwest to overwintering sites in southern and central California.

ARTIST'S NOTE: *When painting birds you have to pay attention to value, lights, and darks. You are often distracted by pattern, texture, and color. These attributes, when painted literally, will make the bird seem flat. So make the bird's form your first priority. Note where the light is coming from and paint accordingly. When painting flight patterns, I was able to remove details and paint form.*

PLATE II

Types of Flight

Flight is the essence of migration and there are several distinct types, including soaring, gliding, flapping, bounding, and powered flight. Species usually use more than one or a combination of types and may change types in response to weather conditions and other circumstances. A particular species often relies more heavily on one type of flight, which provides a useful characteristic for identifying a bird in the field. Perhaps the easiest way to understand different types of flight is by looking at the flight styles of the familiar bird species in this illustration.

Right: In this image, Broad-winged Hawks are using "thermal soaring." By circling on rising warm air currents, or thermals, they gradually gain altitude while expending very little energy. Forming large migratory flocks (the largest of any hawk), hundreds of Broad-winged Hawks sometimes can be seen rising slowly

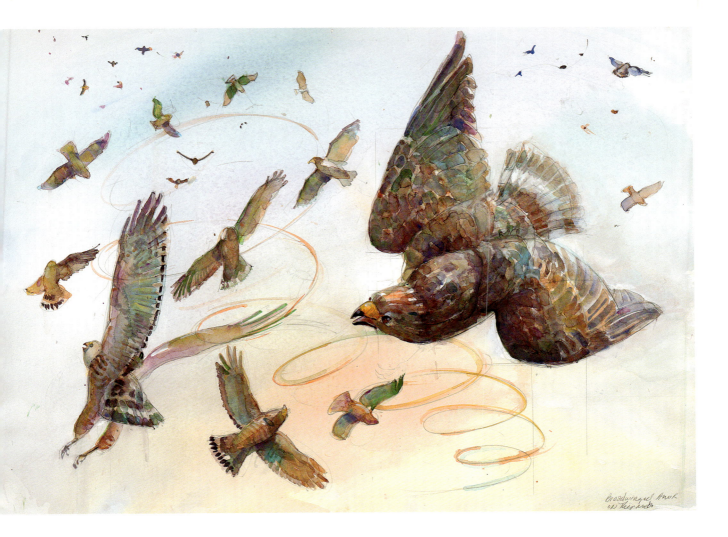

Broad-winged Hawk
on Kestrels

on thermals. These circling groups are called "kettles." When they reach a sufficiently high altitude, individual birds head off in the desired direction until they reach another thermal. There the "kettling"—gathering and circling upward—is repeated. This type of flight is most commonly seen in birds with broad wings, such as hawks, vultures, and cranes. Their daily migrations are timed to coincide with the occurrence of thermals, which usually get going around midmorning.

Left panel: In the upper left, swallows are using "gliding flight" in which the wings are held out in a fixed position. They keep moving through occasional flapping, with the length of the gliding period depending on wind speed and direction. The cranes on the right are shown alternating between flapping, powered flight, and gliding—a necessary strategy for many larger birds.

Right panel: At the top, a Great Blue Heron is seen in "undulating flight." Due to their weight, Great Blue Herons lose altitude when they glide. As they alternate between periods of flapping and gliding, their flight path undulates. The middle images represent birds, such as orioles, finches, and woodpeckers, which use "bounding flight." This style of flight alternates flapping with periods of ballistic gliding, in which the wings are closed against the body. Hummingbirds (bottom) fly by "continuous flapping." This type of flight also is common in birds with smaller wing areas, such as ducks and rails.

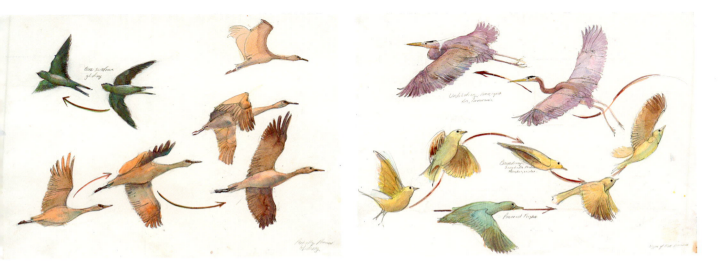

PLATE III

February Gull Frolic

Gulls are on the move by February: drawn to the Great Lakes by the breaking ice, moving into inland lakes to breed, or heading north to arctic breeding grounds. During this February gathering of birds and birdwatchers, up to seven different species of gull might be spotted at a particular gulling "hotspot" on Lake Michigan near the Illinois-Wisconsin border: Ring-billed, Herring, Thayer's, Iceland, Glaucous, Greater Black-backed, and Lesser Black-Backed. Gulls carry out marvelous feats of flight acrobatics as they compete for pieces of bread thrown into the air by birders on this special day.

ARTIST'S NOTE: *Yes, there really is an event called the Gull Frolic that occurs in February each year in Waukegan, Illinois. Hardy birdwatchers come from all over the region to look for rare species among the thousands of Herring and Ring-billed Gulls congregating along the lakefront. I did this plate from a photo taken by Arlene Kozoil, a bird photographer who volunteers in the Field Museum's Division of Birds Prep Lab once a week. Her photographs captured some of the stories I wanted to tell about birds and migration.*

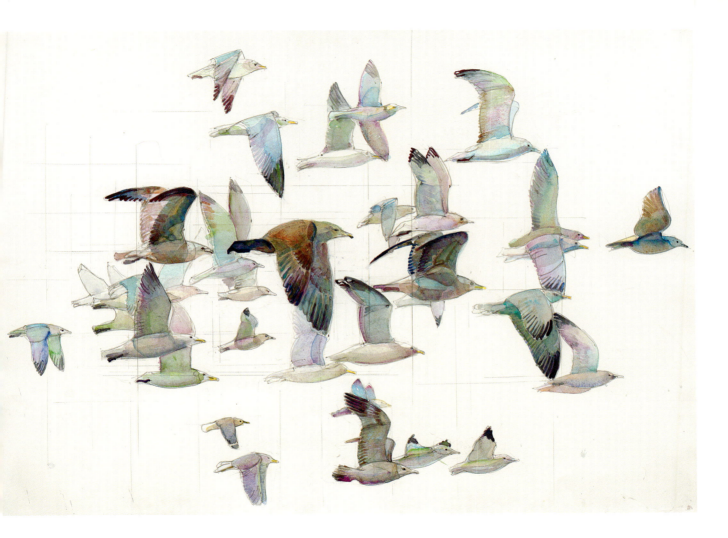

ARTIST'S NOTE: *It took three attempts to begin to master the unique choreography of a mass of European Starlings. Their graceful movement en masse was hard to depict because there was such a variety of flock shapes to choose from. This too is another example of birds adhering to Ruskin's laws. His law of consistency reads, "While contrast displays things, it is unity and sympathy, which employ them, concentrating the power of several into a mass."*

PLATE IV

Flocking STARLINGS

European Starling

Order Passeriformes, family Sturnidae,
Sturnus vulgaris

In fall and winter, European Starlings often travel and roost in large groups, sometimes with other birds like Grackles, Red-winged Blackbirds, and Cowbirds. Among the most wondrous sights of nature are these huge flocks, wheeling, turning, landing, and lifting off as if all of one mind, a behavior known as murmuration. Scientists studying this phenomenon from a systems perspective call it "scale-free behavioral correlation." They have found that while these loosely ordered groups have no particular leaders, individuals responding to immediate disturbances (such as a predator) are quickly imitated by adjacent individuals; the response can travel rapidly throughout a flock, no matter how large. (See also plate XXXVIII for more about starlings.)

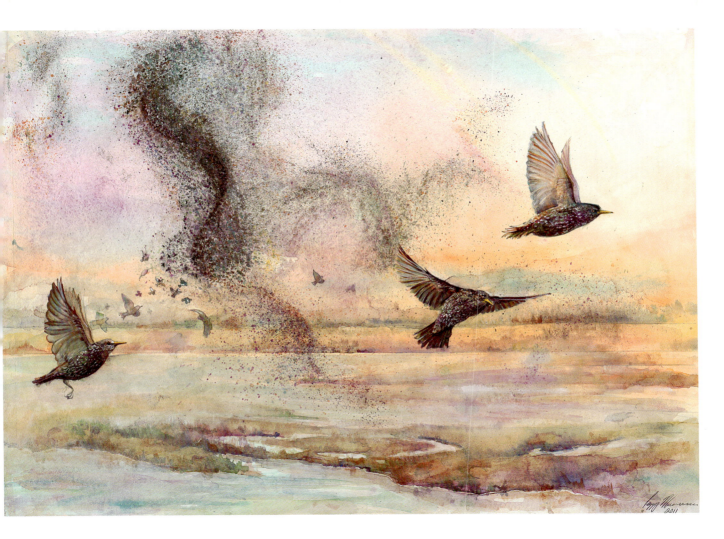

ARTIST'S NOTE: *Rendering movement makes me appreciate animators. They paint things frame by frame, which reminds me that time should never be a consideration if possible. Things take however long they take. The artist does not lack ability if the image takes longer. He or she is just persistent and knows when something is right. The image in the foreground represents a single frame of dragonfly movement, and the images in the background show several frames isolated to show upward and downward movement.*

Black saddlebags
Order Odonata, family Libellulidae, *Tramea lacerate*

This dragonfly is on the wing almost continually during the day and even eats and mates in flight. It is also one of the nine or ten dragonfly species known to migrate, with many individuals joining large swarms of green darners and gliders heading south in August and September. (See also plate XVIII.)

PLATE V

Dragonfly Flight

Dragonfly wings are considered primitive compared to those of most other insects, and the fossil record suggests that not much has changed since dragonflies first evolved three hundred million years ago. Dragonflies have two wings on each side, which they hold straight out while perched. Unlike most other insects, the four wings are similarly shaped, and in flight the two pairs act independently. Attached to muscles inside the dragonfly's body, the wings move up and down on a relatively straightforward hinge mechanism, like rowing through the air. Maneuvering them in alternating phases, dragonflies hover, glide, and even mate in flight. The clacking sounds we sometimes hear coming from dragonflies are the front and back wings hitting each other. During migrations, dragonflies, like birds, rise up into the air where they catch winds that help propel them in the right direction.

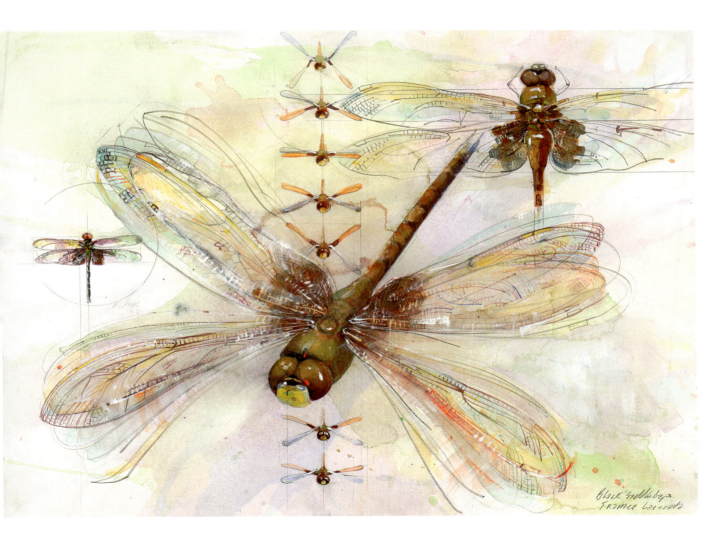

Black-tailed skimmer.
Tramea lacerata

ARTIST'S NOTE: *It helps to develop a system of givens when working as an artist. A consistent size, medium, subject, and process make "going to work" easy. But at the same time it helps to change one of the variables and see what happens. This usually leads to a few flops, but you come out learning something new. Butterflies in flight were something new for me. Painting them allowed me to present a species in a new way.*

PLATE VI

Butterfly and Moth Flight

Like dragonflies, butterflies and moths have two pairs of wings. In some more primitive forms all four wings are similar in size, but in the majority of butterfly and moth species the forewings are larger than the hind wings. Butterflies and moths move their wings in figure-eight motions to push air and provide lift. In flight, the front and hind wings of moths are linked by a bristle (frenulum) or a membranous flap (jugum), so both wings move up and down in synchrony. But-terflies, however, lack these structures. Instead, their wings overlap, and the power stroke of the forewing pushes down the hind wing in unison. They fly with a peculiar lurching motion because their wings push much more air than they need just to hold them up. It might seem inefficient, but the motion makes it harder for predators to catch them. Like dragonflies, migrating butterflies get help from prevailing winds.

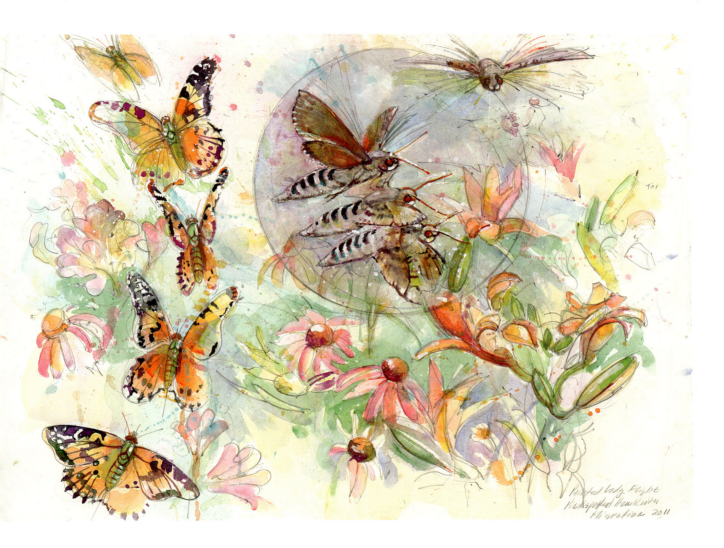

Painted Lady Flight
Fivespotted Hawkmoth
Migration 2011

1 Painted lady

Order Lepidoptera, family Nymphalidae, *Vanessa cardui*

Seemingly delicate, painted ladies are able to fly a thousand miles or more from their tropical wintering grounds. In spring and early summer they arrive in massive swarms, quickly repopulating most of North America, including Illinois. (See also plate XXV.)

2 Ello sphinx moth

Order Lepidoptera, family Sphingidae, *Erinnyis ello*

While hovering in midair, sipping nectar from flowers, the Sphingidae are often mistaken for hummingbirds. Sphinx moths, also known as hawk moths, fly fast and strong; with rapid wingbeats, some can fly up to thirty miles per hour. (See also plate XXII.)

SPRING

As the Earth slowly tilts its top toward the sun, winter releases its grip on the Northern Hemisphere, and changes take place across the land. Ice on streams and ponds thins and eventually disappears, and the first plants break through lingering snows. With these changes comes the emergence of overwintering insects and the much-anticipated migration of birds.

Some species apparently cannot wait and arrive even before the thaw. The first male Red-winged Blackbirds of the Midwest spring may be heard singing in the midst of February snowstorms. Newly thawed ponds welcome other early migrants—namely, waterfowl. Flying formations of migrating ducks and geese offer tangible and highly visible signs of spring. Eastern Bluebirds and robins, including some that have wintered here, begin welcoming their migratory brethren to the region even as other species that spent the winter here, such as tree sparrows, prepare to head north on their own migratory journeys.

These hopeful signs of spring are bolstered in March as insect and bird activity increases. On warm

days, water striders skim the surfaces of still ponds. More temperate conditions also entice butterflies, such as mourningcloaks and Milbert's tortoiseshells, to leave winter hiding places. These species overwintered as adults, tucked deep in crevices in tree bark or rocks, and so can take advantage of early spring warmth. Bumblebee queens, too, emerge from snug winter burrows in soil and begin the search for suitable nest sites. A succession of migrating sparrows brings last year's leaf litter to life as they scratch in search of seeds and other food. Female Red-winged Blackbirds and Common Grackles also make the scene.

April brings more insects—and insect eaters. Ants and wasps are commonly seen out and about, busily building their nests. Swallows feast on hordes of insects that arise from swamps and marshes, and pond edges come alive with migrating shorebirds stopping to refuel. April also welcomes the first warblers, the earliest being Yellow-rumped Warblers.

By May, migration is in full swing as waves of colorful warblers and other song birds that spent the winter in the West Indies and Central and South America reach the area. On the best days, trees pulsate with flashes of red, orange, yellow, green, and blue feathers. On a quiet night, you may hear a faint chorus of flight calls as thousands of thrushes and others birds make their way along the lakefront. The air is also filled with the migratory fluttering of butterflies, including sulphurs and other species returning from more tropical southern climates.

For birders and lovers of spring alike, this is one of the year's most exciting times. During this flurry of migratory activity, Chicago-area birders are eager to get a good look at the new visitors. But as May draws to a close, so does the rush of migration, and nature moves on to the business of nesting and raising young.

PLATE VII

Herald of Spring

RED-WINGED BLACKBIRD

Red-winged Blackbird
Order Passeriformes, family Icteridae,
Agelaius phoeniceus

In late winter, Red-winged Blackbird males begin to abandon the huge roosts in the southern United States where they spent the winter to migrate to breeding areas. They establish territories in marshes, moist grasslands, and fields, advertising their ownership by sitting high on tall vegetation and singing. Streaky-brown females, who look like large sparrows, arrive later to choose a male and his territory. Ten or more females may share a single male's territory. During the breeding season, males aggressively defend their territories, females, and nests, attacking other males and potential predators. Some will even dive at people who walk too near their nests. In fact almost every spring in Chicago, Red-winged Blackbird "assaults" on people make the local news. Although these encounters may be startling, they can be avoided by giving the protective father a wider berth.

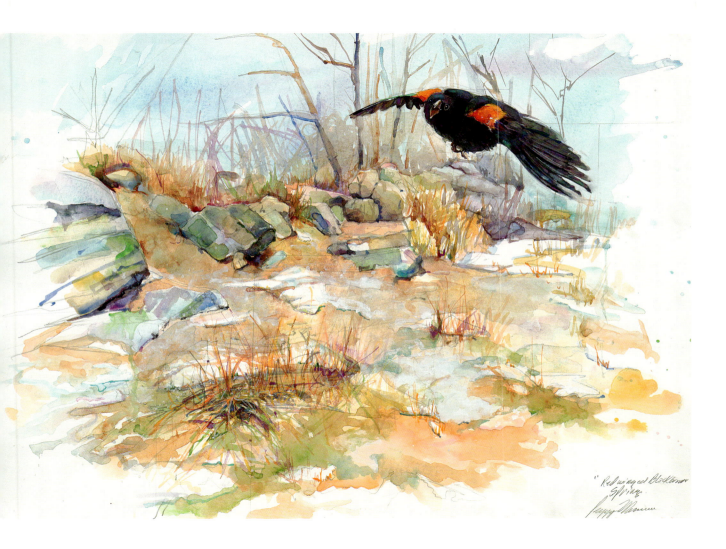

"Red-winged Blackbird"
Spring.

Peggy Macnamara

PLATE VIII

Early Arrivals of Summer Residents

SPARROWS

ARTIST'S NOTE: *The first big wave of spring migrant songbirds is the sparrows. Lots of browns! I build all my browns by layering complimentary colors: reds and greens and blues and oranges. With no apparent order, I begin and then it is too green, so it requires a wash of sienna or red (not a cadmium). Then it appears a bit orange, so I go with blue. And so on. It would probably be easier to just use sepia, but I like the process. The study skins that appear on the right side of the plate are arranged from top to bottom in the order that the different sparrows generally arrive in Chicago each spring: Song, Swamp, Chipping, Field, White-throated, Grasshopper, and White-crowned.*

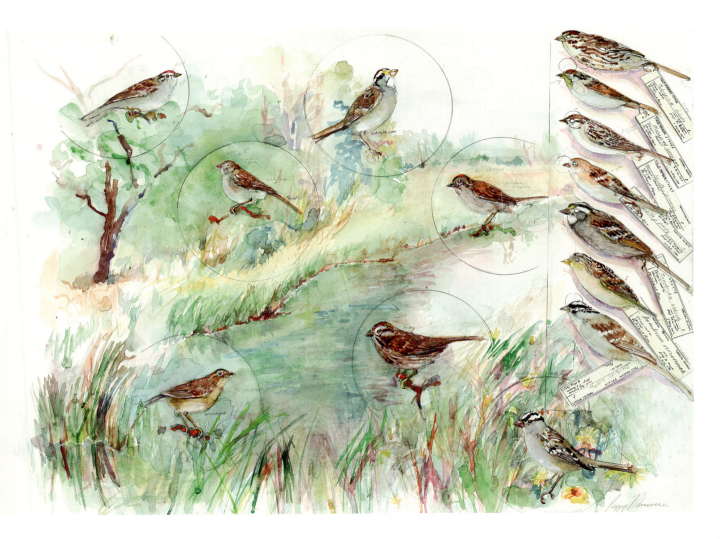

1 Chipping Sparrow

Order Passeriformes, family Emberizidae, *Spizella passerina*

This appealing little sparrow is both common and widespread; it can be found nesting in suburban yards, gardens, and forests—almost any place where trees and grassy openings combine. Among the smallest sparrows, Chipping Sparrows have a bright Rufous-colored cap, strongly bordered by a white eyebrow stripe and a black eye line. They winter in the southern United States and Mexico, with many migrating as far north as eastern Alaska and Canada to breed.

2 Field Sparrow

Order Passeriformes, family Emberizidae, *Spizella pusilla*

As the name implies, Field Sparrows are birds of fields, pastures, and clearings. They're usually heard first, singing the same note faster and faster, sounding like a bouncing ping-pong ball. Another rusty-capped sparrow, the Field Sparrow is distinguished by a pink bill and the absence of an eye line.

These sparrows breed throughout the central and eastern United States; many nest around the Great Lakes and some remain all year. In winter, they leave the most northern areas and extend their range into Mexico and Florida.

3 White-throated Sparrow

Order Passeriformes, family Emberizidae, *Zonotrichia albicollis*

One morning in early April, hundreds of these energetic sparrows will appear in yards and parks, especially along the lakefront. Their pretty, insistent song, *Oh sweet Canada*, announces their arrival; then you'll spot small flocks on the ground or in low bushes searching for seeds and buds to eat. The bright yellow spot between the eye and bill of this sparrow complements its white throat and black-and-white striped head. White-throated Sparrows winter in the southeastern United States and migrate north to breed in forests across Canada and in the mountains of the northeastern states.

4 Swamp Sparrow

Order Passeriformes, family Emberizidae, *Melospiza georgiana*

Swamp Sparrows nest in Illinois and a few stay the winter, but spring finds thousands of these sparrows passing through Chicago on their way to breeding grounds in Canada and more northern states. During migration and breeding season, this sparrow can be recognized by its rusty cap and wings along with a dark eye line and jaw stripe.

5 Grasshopper Sparrow

Order Passeriformes, family Emberizidae, *Ammodramus savannarum*

Grasshopper Sparrows are aptly named in more ways than one. Their name reflects a diet of insects (including many grasshoppers) and also their buzzy, grasshopper-like song. They build their nests on the ground. Dwindling grassland habitats and nest losses from early cutting or harvesting have caused this sparrow to decline. This shy sparrow winters in the southeastern United States, Mexico, and the Caribbean, migrating north to breed across a huge area of southern Canada and the northern United States, including Illinois.

6 Song Sparrow

Order Passeriformes, family Emberizidae, *Melospiza melodea*

This common sparrow is found in fields and yards throughout North America. Song Sparrows have white breasts heavily streaked with brown and a central "tie tack"—a heavy, brown spot that is a key field mark. Like White-throated Sparrows, the peak of migration for Song Sparrows in Chicago is April. Resident in some places and migratory in others, this sparrow's breeding range extends from southwestern Alaska across Canada to Newfoundland and south to northern Mexico and northern Georgia. A "leapfrog" migrant, Song Sparrows that breed farther north also migrate the farthest, leapfrogging the central populations to spend winter in the southern United States and northern Mexico.

7 White-crowned Sparrow

Order Passeriformes, family Emberizidae, *Zonotrichia leucophrys*

This sparrow has an eye-catching black-and-white head that contrasts with its gray breast. The White-crowned Sparrows' buzzy trills accompany their early May arrival in our area. These sparrows are passing through, headed for their nesting grounds in the far northern areas of Alaska and Canada. While in Chicago, White-crowned Sparrows feast in large numbers in dandelion patches and elm trees filled with buds and seeds.

PLATE IX

Dave's Big Four

ARTIST'S NOTE: *One of the great things about painting at the Field Museum is the bits you learn about each scientist and how his or her interest in science developed. When Dave Willard was very young, he witnessed these four migrant species feasting on apples. This breathtaking sight was the beginning of a rich life in science for Dave, and whenever he is able to spot these four birds on the same day, he says that it is a "great day birding!" Often as artists we expect a loud calling when all we will get is a "great day painting!" If you love doing it, then it's your calling. "How good you are" should not be a consideration.*

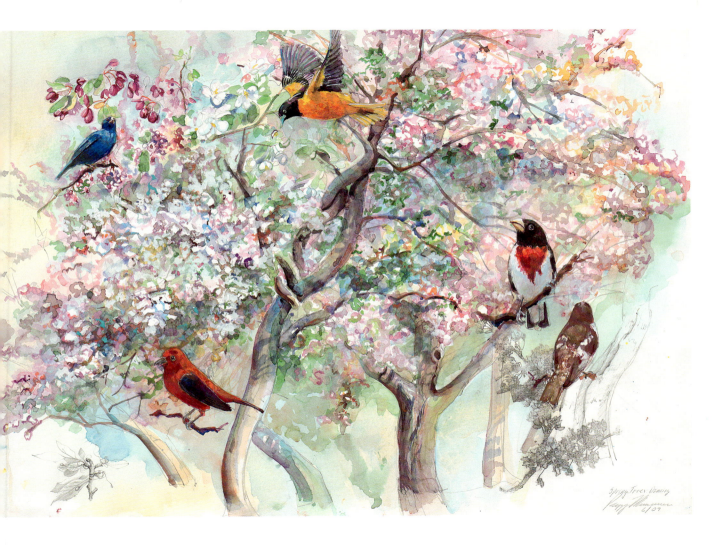

Spring Trees Visitors
Guy Coheleach 6/09

1 Baltimore Oriole

Order Passeriformes, family Icteridae, *Icterus galbula*

A common migrant and breeder in wooded city parks and suburbs, the colorful Baltimore Oriole is a much-anticipated spring arrival for those who watch and feed birds. Despite a Baltimore Oriole's bright orange color, its loud, whistling song typically announces its presence before it is sighted. Its nest resembles a hanging basket, often placed at the end of flimsy branches; this keeps predators from reaching it. American orioles are not closely related to the true orioles (Oriolidae family) in the Old World but are in the same family as blackbirds and meadowlarks. These birds winter in Florida, the Caribbean, central Mexico, and Central America into northern South America.

2 Rose-breasted Grosbeak

Order Passeriformes, family Cardinalidae, *Pheucticus ludovicianus*

(*Male and female*) A lucky spring birder around Chicago may spot a small group of these striking birds before they disperse into breeding territories. Male Rose-breasted Grosbeaks are easy to identify, with their large bills and distinctive coloring of black, white, and deep rose. The female is more difficult, looking somewhat like a large sparrow or finch. Rose-breasted Grosbeaks nest in deciduous and mixed woodlands, along forest edges, and in open woodland habitats such as orchards, parks, and gardens across temperate North America, including Illinois. They winter in tropical America, traveling as far as 2,500 to 5,000 miles into Mexico, South America, and the Caribbean.

3 Scarlet Tanager

Order Passeriformes, family Cardinalidae, *Piranga olivacea*

Scarlet Tanagers breed in Illinois but only in larger patches of forest like the county forest preserves. The dazzling male has a bright red body with contrasting black wings, while females have an olive green body with darker wings. Beautiful but elusive, this bird is usually spotted high in the trees where it nests and, like many birds, found most easily through hearing its song. Scarlet Tanagers breed in intact woodlands and mature forests in southern Canada and throughout much of the eastern United States. Since they rely on fruit and insects for food, Scarlet Tanagers move to warmer climates in winter, journeying from 600 to 4,350 miles across the Caribbean and into South America.

4 Indigo Bunting

Order Passeriformes, family Cardinalidae, *Passerina cyanea*

The first Indigo Bunting males to arrive in April may still have some brown in their plumage. But they soon become fully brilliant blue, with the most intense indigo color on the head. As an added bonus, they frequent open habitats—open woods and fields, and the edges of cultivated areas (including orchards), woods, and roads—providing wonderful viewing opportunities. They breed across the entire eastern United States. In winter they range throughout the Caribbean and Central America.

PLATE X

Spring Migrant Warblers in the Chicago Area

(SEE PLATE XXXIV FOR THE SAME WARBLERS IN FALL PLUMAGE.)

When the wave of spring warblers arrives, the brightness and energy of the spring foliage tends to bury these small birds; you have to listen as well as look.

ARTIST'S NOTE: *In the Botany Department at the Field Museum, Robin Foster recorded plant specimens by using a copy machine. The resulting images were incredibly accurate. So I borrowed this technique by copying a plant specimen and then transferring the image (actually the printer's toner) to my watercolor paper with a blender. As visible on the lower right of this plate, it appears to mix right in with my impressions.*

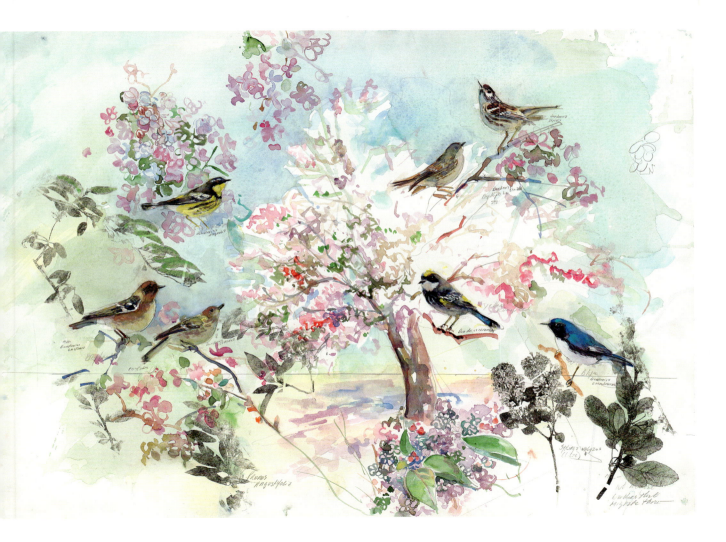

1 Blackpoll Warbler

Order Passeriformes, family Parulidae, *Setophaga striata*

(*Male and female*) In spring, Black-poll Warblers pass through the Chicago region en route from their wintering grounds in northern South America to nesting grounds in the coniferous forests of Alaska and northern Canada. Many male warblers have brightly colored plumage during breeding season: the Blackpoll is told by its black cap, white cheek, black mustache stripe, and white throat. Many female warblers appear to blend into the foliage. Blackpoll females are gray to olive green with blackish streaks.

2 Yellow-rumped Warbler

Order Passeriformes, family Parulidae, *Setophaga coronata*

(*Male*) Other warblers have yellow rumps but none as obvious as this species. Once considered separate species, the two forms of Yellow-rumped Warbler—Myrtle in the East and Audubon's in the West—now are considered the same species. A liking for bayberries and wax myrtles gives the Myrtle form its name and also allows it to winter well into the northeastern states where the berries are found. These warblers breed across the conifer-ous forests of North America—the farthest north of any of the warblers—with a few staying in the Chicago region all winter. The majority of individuals winter in the southern United States. Because Yellow-rumped Warblers breed and winter over a broad area, their migration distances can vary from 300 to 6,000 miles.

3 Black-throated Blue Warbler

Order Passeriformes, family Parulidae, *Setophaga caerulescens*

(*Male*) A distinctive migrant that birders love to see, this species' main migration route, through the northeastern United States, makes it one of Illinois's less common visitors. Identified by a white "handkerchief" on the wing, its plumage remains the same in spring and fall. These warblers further differentiate themselves by favoring the understory of deciduous and mixed woodlands. Black-throated Blues summer in the northern Great Lakes region and south into the Appalachian Mountains and travel to the West Indies for winter. Migration distance ranges from 1,500 to 4,000 miles.

4 Bay-breasted Warbler

Order Passeriformes, family Parulidae, *Setophaga castanea*

(*Male and female*) In spring, Bay-breasted Warbler males have a rich chestnut-colored head and throat, while females are paler with a hint of orange on the throat and sides. A fairly common migrant through Chicago, this warbler breeds in Canada down to the northeastern edge of the United States and travels in autumn all the way to Panama and Venezuela, a migration journey ranging from 2,175 to 3,400 miles.

5 Magnolia Warbler

Order Passeriformes, family Parulidae, *Setophaga magnolia*

(*Male*) One of the more common species to migrate through the Chicago region, the Magnolia Warbler is often referred to as the black-and-yellow warbler. The spring male's yellow chest and throat, black necklace, and black eye mask give it a handsome appearance. The Magnolia Warbler's name comes from the tree species where one of the first specimens was collected. Its song is similar to the Yellow Warbler's but shorter. The Magnolia Warbler breeds in Canada and the northern United States, traveling to Mexico, Central America, and the West Indies for the winter—a distance of 1,500 to 4,000 miles.

ARTIST'S NOTE: *Transparency is watercolor's strong suit, so I use it whenever possible. For this painting, I began with the map image and layered the birds on top. Often using almost thirty layers of transparent color, I am able to build up the richness of color to be comparable to that of an oil painting.*

PLATE XI

Spring Storm Aftermath

In May 1996, a chance stroll on the lakefront the morning after a violent storm resulted in the discovery of a large number of dead birds washed up on the beach. Over the next two weeks, Tom Gnoske, museum staff, and volunteers salvaged nearly three thousand birds of 114 species from beaches on the North Side of the city—which represents only a fraction of the disaster. All these birds had drowned while flying across Lake Michigan, clear evidence of the dangers large bodies of water present to migrant song birds.

We have traced the cause of this mortality to several severe evening storms that coincided with nights of heavy migration. Spring of 1996 also was marked by unusually strong easterly winds, which pushed the drowned birds toward the lake's western shores. Had the winds been predominately out of the west, as they

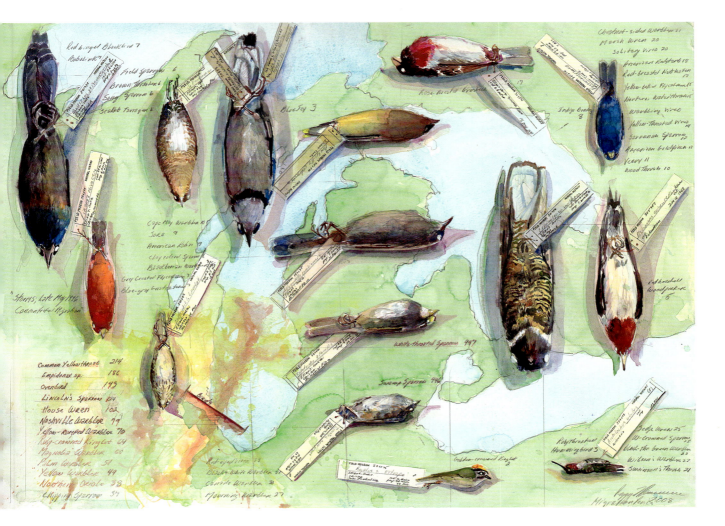

are in most years, we likely would have been unaware of the effect of these storms.

When huge numbers of birds are moving together, there is always the potential for mass mortality from storms. At a time when our focus tends to be on human-related causes of bird death (e.g., house cats and collisions with glass windows, cars, trucks, and electric transmission lines), this is a reminder that natural sources of mortality, on occasion, dwarf all others.

Drowned birds found after the 1996 spring storms (number of individuals collected in parentheses): *right side, clockwise from upper right*, Indigo Bunting (8), Red-headed Woodpecker (5), Eastern Whip-poor-will (2), Ruby-throated Hummingbird (3), Golden-crowned Kinglet (2), Swamp Sparrow (446), White-throated Sparrow (497), Gray Catbird (127), Cedar Waxwing (1), Rose-breasted Grosbeak (17); *left side, clockwise from center upper right*, Blue Jay (3), Lincoln's Sparrow (124), Scarlet Tanager (6), Common Grackle (7), Yellow Rail (2).

Partial species list of specimens that were counted but not pictured: Common Yellowthroat (214), *Empi-*

donax genus flycatchers (186), Ovenbird (143), House Wren (102), Nashville Warbler (79), Yellow-rumped Warbler (70), Ruby-crowned Kinglet (64), Magnolia Warbler (60), Palm Warbler (51), Yellow Warbler (49), Northern Oriole (38), Chipping Sparrow (37), Red-eyed Vireo (33), Black-and-White Warbler (31), Canada Warbler (30), Mourning Warbler (27), Cape May Warbler (10), Sora Rail (9), American Robin (9), Clay-colored Sparrow (8), Great-crested Flycatcher (7), Blue-gray Gnatcatcher (7), Bobolink (7), Field Sparrow (6), Brown Thrasher (6), Song Sparrow (6), Chestnut-sided Warbler (21), Marsh Wren (20), Solitary Vireo (20), American Redstart (18), Red-breasted Nuthatch (17), Yellow-bellied Flycatcher (15), Northern Waterthrush (15), Yellow-throated Vireo (14), Savannah Sparrow (12), American Goldfinch (12), Veery (11), Wood Thrush (10), White-crowned sparrow (25), Black-throated Green Warbler (22), Wilson' s Warbler (27), Swainson's Thrush (21).

ARTIST'S NOTE: *There are many ways to depict a bird against a sky, but I find it best to wash the sky through the image of the bird, rather than bring the sky color up to the edge of the bird. You can always lift out the sky color from the bird form while it is still wet. This enables you to avoid the awkward edges where the sky and bird meet. It provides a smooth figure-ground presentation.*

PLATE XII

Ducks in Flight NORTHERN SHOVELER

Northern Shoveler
Order Anseriformes, family Anatidae,
Anas clypeata

We have all seen flocks of ducks in flight. Approximately one hundred million American ducks migrate each fall, traveling in both large and small flocks. Spring travelers are fewer in number due to winter loss. Spring flocks are smaller, too, usually around thirty. Changes in weather and the availability of the wetland habitats on which they depend may cause ducks to alter their migratory routes.

Pale blue forewings, bordered by white and green, combined with distinctive shovel-like bills, are the keys to recognizing Shovelers in flight. Shovelers neither breed nor winter here but migrate through in small flocks, generally ten to twenty-five birds. Chicago lies on one of two main flyways used by migrating Shovelers. The easternmost flyway follows the Mississippi and Missouri valleys and central plains states down to the Gulf Coast and Mexico. The other extends from Alaska and western Canada down through California to the Mexican coast. Spring migration may bring them to our area as early as mid-March. (See the cover plate to find out about the V-shaped flight formation.)

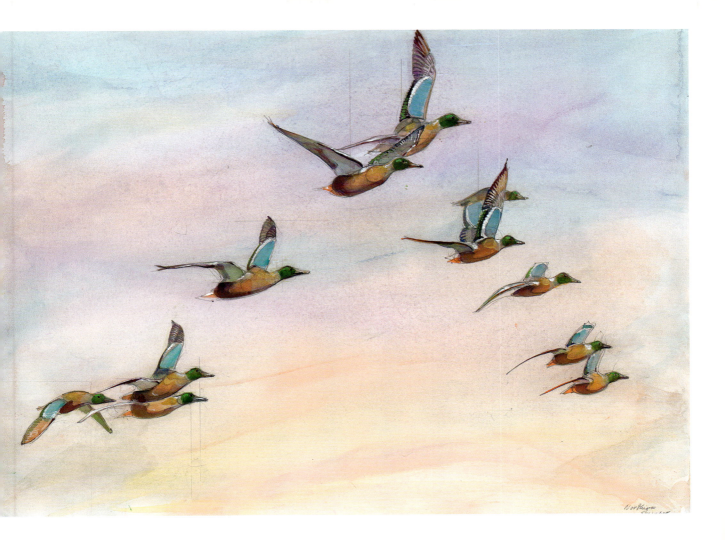

PLATE XIII

Spring Field Insects

ARTIST'S NOTE: *Painting insects will teach you about painting texture. Take bees, for instance. They have a hard and shiny surface as well as dense hairs and transparent wings. The hairs I render with a variety of dark colors, layer by layer. When the first few layers of jagged marks are dry, I go over them with another to create the illusion of depth. Finally I draw the wing on top and, with a bit of water on my brush, scrub out some of the color within the lines of the wing, leaving an after image of the hairs, suggesting the wing's transparency.*

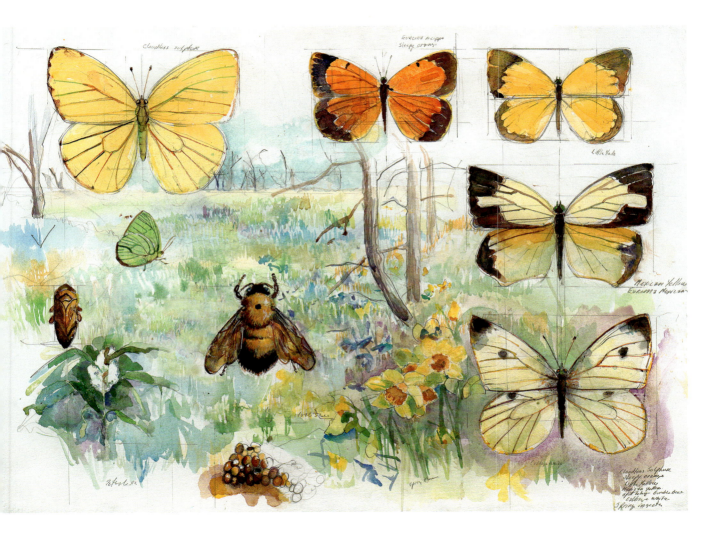

Cloudless sulphur

Eurema Nicippe
Sleepy orange

Little Yellow

Mexican Yellow
Eurema Mexicana

Cloudless Sulphur
Sleepy orange
Little Yellow
Mexican Yellow
Yellow Bumble bee
Cabbage white
3 King insects

1 Cloudless sulphur

Order Lepidoptera, family Pieridae, *Phoebis sennae eubule*

The cloudless sulphur is a relatively large, bright yellow butterfly with a wingspan of two to three inches. Butterflies of the genus *Phoebis* generally live in the tropics and subtropics; this is the only species that regularly comes into Illinois. Although they breed here in summer and early fall, cloudless sulphurs do not survive winter's freezing temperatures. They must migrate into the state again each year. In some years, they make it only as far as Illinois's southern counties; in other years, they spread as far north as Chicago.

2 Sleepy orange sulphur

Order Lepidoptera, family Pieridae, *Eurema nicippe*

The sleepy orange rarely survives Illinois winters but migrates anew each year from southwestern states. In the south, these butterflies overwinter as adults. Present but never common in Illinois, they're typically found each year in habitats with legumes such as cassia—the host plants for their caterpillars. The sleepy orange may be found in damp sites, meadows, roadsides, and prairies, and is an erratic and often rapid flier when frightened. Varying in color across warmer months, summer adults usually have yellow undersides, while fall individuals are more reddish orange underneath.

3 Little yellow

Order Lepidoptera, family Pieridae, *Pyrisitia lisa*

Living year-round from Texas down through Mexico and Costa Rica, little yellows migrate each year north and east to colonize most of the eastern United States. They fly low in open areas and are often seen at mud puddles. Butterflies need more nutrients than just the rich sugar found in nectar. To help meet their nutrient needs, they sip moisture from mud puddles, taking in salts and minerals from the soil. Known as "puddling," this behavior is often seen in males. They incorporate the extra salts and minerals into their sperm, improving the viability of the females' eggs.

4 Mexican yellow

Order Lepidoptera, family Pieridae, *Eurema mexicana*

This neotropical butterfly is a resident from the southwestern United States down into Central America and is a very rare migrant to Illinois. It has been recorded in Cook, DuPage, and Kane Counties. Its appearance in Illinois is sporadic, and most sightings have not been in the spring but late summer and fall. The Mexican yellow is creamy white with irregular black margins on its forewings that outline a "dog's head" shape. The hind wings have short tails. Mexican yellow caterpillars feed on plants in the pea family such as *Acacia* and *Diphysa*; adults take nectar from many different flowers.

5 Cabbage white

Order Lepidoptera, family Pieridae, *Pieris rapae*

Cabbage whites are aptly named—they are white butterflies that eat cabbage during their caterpillar stage, when they are also known as cabbageworms. Originally from Eurasia, they were accidentally introduced to North America around 1860. Cabbage whites overwinter as pupae. In early spring, adults are one of the first butterflies to appear in fields and meadows. Watch for a behavior called "spiral flight," which the female initiates to avoid additional courtship attempts after she mates. It starts with a male and female circling around each other near the ground. Then the female rises in spiral flight and the male follows. After reaching heights of up to sixty feet, the male gives up and drops straight down, while the female descends slowly, allowing time for the male to move away. She then carries on with laying her eggs singly on the leaves of food plants.

6 Bumblebee

Order Hymenoptera, family Apidae, *Bombus impatiens*

Fertilized bumblebee queens hibernate in soil during winter and on warm spring days can be seen flying about looking for nest sites. Once settled, the queen starts to collect pollen. A bumblebee's legs have concave structures surrounded by a fringe of hairs—pollen baskets—into which pollen is placed. When pollen baskets are full, the bee appears to have chunky yellow legs. The queen uses some of this pollen to produce honey that she will store in wax (a "honey pot"). She also lays her eggs in pollen mixed with some of the honey—called "bee bread." She covers the eggs with wax and sits on the pile, feeding her young from the honey pot while they develop. Larvae also feed on the bee bread. The larvae pupate in tough individual cocoons, as illustrated below the bumblebee in the plate.

7 Meadow spittlebug

Order Hemiptera, family Cercopidae, *Philaenus spumarius*

Spittlebugs are best known for their habit of creating frothy white balls of "spit" on plants, which you may see as early as mid to late April. That's when spittlebug eggs that overwintered on plant stems begin to hatch; the yellow to orange nymphs start making spittle right away. Nymphs live inside the froth, which provides cover, regulates temperature, retains moisture, and deters predators with its awful taste. Adults are heavy-bodied, wedge-shaped insects about one quarter-inch long and usually mottled brown and cream in color. They can jump from plant to plant, reaching distances of one hundred times their body length.

PLATE XIV

Warblers That Nest in the Chicago Area

ARTIST'S NOTE: *I find that one of the secrets of painting bright color is using all the adjacent colors on the wheel. For instance, with the purple tulip, I bring in pinks and reds and even blue-violets. The light will hit all areas of the petal in a slightly different way. If you look closely at a flower outside, you will see the various degrees of color.*

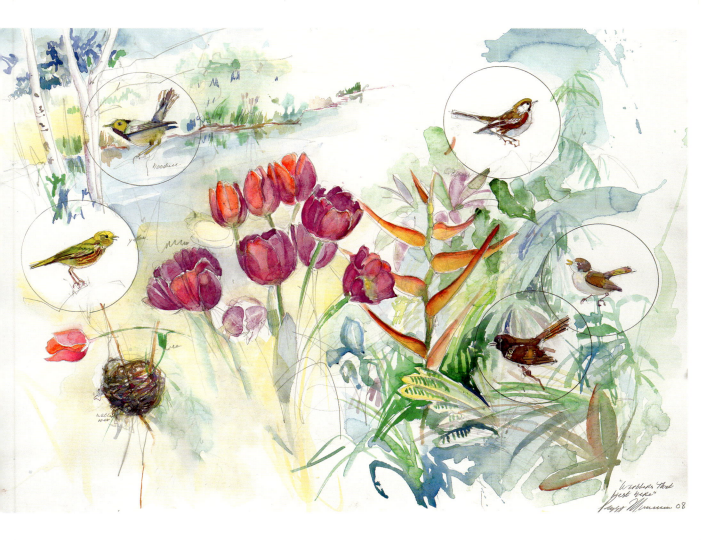

"Warblers that
nest here"

[signature] 08

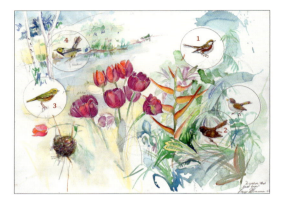

1 Chestnut-sided Warbler

Order Passeriformes, family Parulidae, *Setophaga pensylvanica*

While experienced birders can identify many migrant warblers by song, this warbler has a song that can be readily recognized by novices—a cheery *pleased, pleased, pleased to MEET-CHA*. Its name tells its major field mark: reddish-brown side streaks. Chestnut-sided Warblers breed in bushy second growth and thickets locally and in northern parts of the eastern United States and southeast and central Canada. During winter, they join flocks of mixed species in Central America and northern South America. Amazingly precise in their migration, which can range from 1,850 to 4,000 miles, an individual Chestnut-sided will return to the same wintering area year after year, joining the same foraging flock.

2 American Redstart

Order Passeriformes, family Parulidae, *Setophaga ruticilla*

(*Male and female*) Sometimes called the butterfly of the forest because of its black and bright orange colors, American Redstarts are constantly on the move. Continual flicking of their patterned tails helps flush out insects to eat. Males are black with orange patches, while females are olive to grayish with yellow flash-patches on tail and wings. Widely distributed, the American Redstart's breeding range sweeps south and east from northwestern Canada down into the Gulf states. In the winter, it migrates between 1,500 and 4,700 miles to southern Mexico, Central America, the Caribbean, and northern South America. A few winter in southern Florida, Texas, and California as well.

3 Yellow Warbler

Order Passeriformes, family Parulidae,
Setophaga petechia

(*Male, with nest*) The name says it
all—it's yellow more so than any
other warbler. Males also sport thin
red streaks on the breast. An early
arrival in Illinois, Yellow Warblers
come in with the first wave of
warblers around mid-April, and
many stay to breed. Its musical
song sounds like *sweet, sweet, sweet,
I'm so sweet.* Yellow Warbler nests
can be parasitized by Brown-
headed Cowbirds, who lay their
own larger eggs among those of
the unsuspecting hosts. But the
warblers have developed tactics
to address the problem—they
abandon the original eggs and lay a
new nest right over the parasitized
nest. Some unlucky pairs end up
with several layers of nests in one
season.

4 Hooded Warbler

Order Passeriformes, family Parulidae,
Setophaga citrina

A striking bird, this warbler
is named for the male's black
hood and bib framing a bright
yellow face. Hooded Warblers are
"easterners," breeding in eastern
hardwood forests with shrubs in
the understory. Locally, they nest
in bottomland forest near rivers.
But during migration, they can be
seen in almost any wooded area,
including city parks, flitting about,
catching insects low in the bushes.
In summer, this warbler ranges
from south Wisconsin, southern
Ontario, and Connecticut south
to the eastern part of Texas and
northern Florida. It migrates 2,500
to 4,350 miles to its winter range in
southern Mexico, Central America,
and the Caribbean.

PLATE XV

Shorebirds

ARTIST'S NOTE: *The third time I attempted this plate, a simple solution just came to me: Paint the shore first and then the birds. Being more interested in the birds, I have begun with them for years, and I believe the habitat has taken a secondary position. I love to paint water. It is abstract yet often has form—that is, a top and side. The top is usually more lit than the side, and you can see that in the water and wave on the left.*

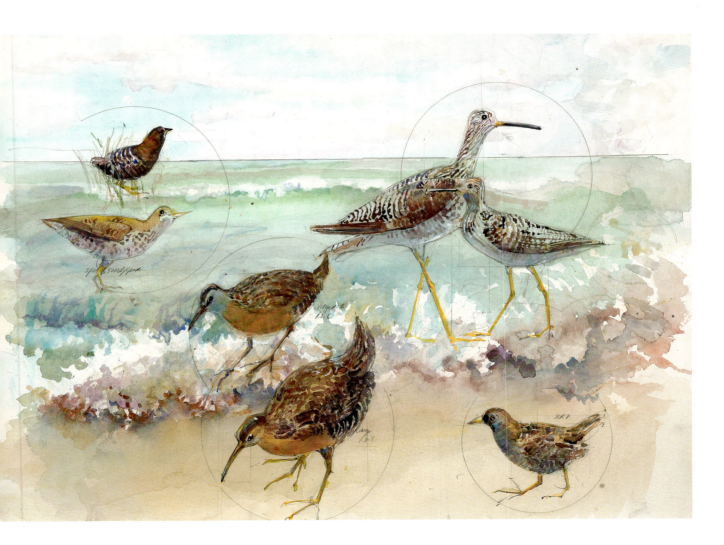

PLATE XVI

Spring Wetland and Woodland Insects

ARTIST'S NOTE: *Don't be deceived by the apparent simplicity of the butterfly. Its composition is more complicated to paint than it first appears. It helps to "crawl" (i.e., draw a slow, light, interior contour line that takes you from one location to the next) through the veins as a way to check location and proportions. Keep your crawling lines light and they will disappear when you apply watercolor. Because a butterfly's wings are made of layers of scales, adding simple layers of transparent paints onto a dry surface seems the best way to keep to the nature of your subject.*

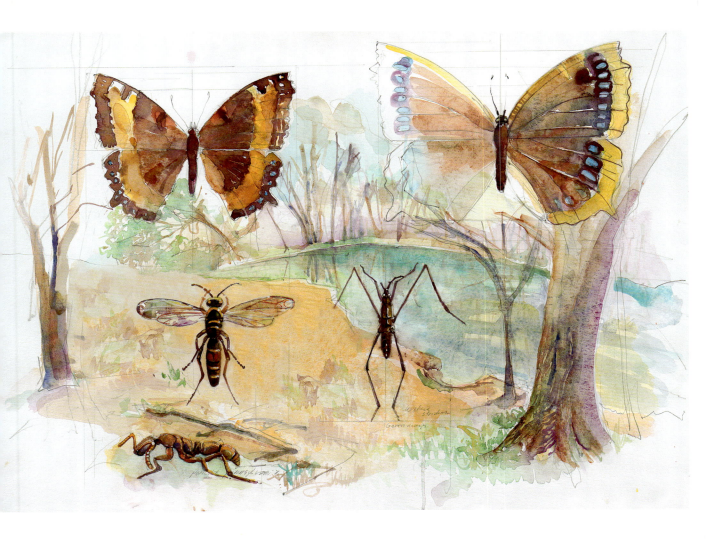

1 Milbert's tortoiseshell

Order Lepidoptera, family Nymphalidae, *Aglais milberti*

These butterfly residents hibernate through winter as adults hidden in hollow trees and logs. Preferring cool northern climates, they can be seen on warm days in early spring feeding on tree sap in wet areas near woodlands and pastures or marshes. In the afternoon, males perch on hillsides to watch for females. After mating, females lay eggs in large batches of up to several hundred on the underside of nettles. Young caterpillars feed together in a silken web, scattering after four molts (about four weeks) to feed alone and then pupate. Milbert's tortoiseshells have two broods a year: one in May and one in October. The May brood dies after laying eggs for the October brood, and it is the October brood that looks for places in the fall to spend the winter hibernating.

2 Mourningcloak butterfly

Order Lepidoptera, family Nymphalidae, *Nymphalis antiopa*

Known as winter butterflies, mourningcloaks can be seen flying very early in the spring. They overwinter as adults and may even become active on warm winter days, heading back to hollow logs or trees when the temperature drops. They mate in spring and the larvae pupate into adults by June or July. Adult mourningcloaks might be active until fall, but biologists think new spring adults might instead go into summer hibernation, reemerging in fall to feed and store energy for winter. In any case, adult mourningcloaks live for ten to eleven months—perhaps our longest-lived butterfly.

3 Common water strider

Order Hemiptera, family Gerridae,
Aquarius remigis

Year-round residents of still waters such as pond surfaces, lakes, and slow-moving streams and rivers, the common water strider lives both on and under the water. In late spring, you can find adults walking on top of the water, sending out ripples to communicate with potential mates. Their feet are surrounded by water-repellent hairs, which prevent the feet from piercing the water's surface. After mating, females break the surface tension and go underwater to lay eggs on rocks or logs. Newly hatched nymphs swim to the surface to live on top of the water once again. As weather cools, adults again go underwater to winter beneath rocks or logs.

4 Common paper wasp

Order Hymenoptera, family Vespidae,
Polistes fuscatus

Queen paper wasps emerge in early spring after overwintering in piles of wood, in vegetation, or in cracks of buildings. You may see them flying around, gathering materials to build their nests: open combs that resemble an upside-down umbrella of cells. Nests are anchored by a stalk and found under building eaves, in attics, in trees, and in open areas sheltered from rain. The queen produces workers all season; in late summer, the next year's queens and their male mates are hatched. New queens are the only colony members to survive through winter. Generally considered beneficial, paper wasps feed on pests, such as caterpillars, that destroy crops and garden plants.

5 Ponera ant

Order Hymenoptera, family Formicidae,
Ponera pennsylvanica

These small ants can be seen in spring enlarging or excavating their nests. Abundant in moist areas, they nest in rotten logs, soil, or leaf mold. Colonies are small, usually no larger than one hundred sterile female workers. They overwinter as adults in colonies that include a queen and workers. The queen resumes laying eggs in the spring, while workers care for the young and find food for the colony. Workers are carnivorous, eating a variety of small invertebrates. Some colonies can survive for several years.

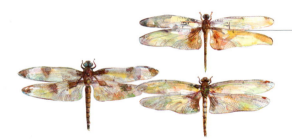

SUMMER

In summer, both permanent residents and those that migrate in to breed quickly get down to the business of the season: nesting, breeding, hatching, and raising young. While spring habitats are full of bird songs that attract mates and announce territories, summer quiets down. Once nesting has commenced, birds become less vocal so as not to draw attention to themselves or their young. Their focus turns to incubating eggs, finding food, and filling the gaping mouths of their young.

In marshes, secretive Soras and Virginia Rails quietly skulk around cattails to reach concealed nests. But occasionally you may hear a Sora's descending whinny. It is also easy to miss the little brown blur of a Swamp Sparrow darting from its nest—hidden low in wetland plants—to snatch insects for its young. Water also attracts herons, egrets, and bitterns for feeding and nesting. While some, such as American Bitterns, nest camouflaged in thick vegetation, others, like Great Blue Herons, form colonies and build prominent nests high in trees. Where woods and water meet,

Wood Ducks may be found; their nests are high above the ground in tree cavities.

Insects also are abundant around summer wetlands, ponds, and lakes. Dragonflies, such as twelve-spotted skimmers and blue dashers, can be seen patrolling in flight or perching on twigs and rocks as they wait for prey to pass by. You may be lucky enough to see a female hovering low, her abdomen dipped in the water. She is laying her eggs. Larvae will develop underwater, living on submerged plants or in debris on the bottom.

In grasslands, the profusion of summer flowers attracts lovers of nectar or pollen. Tiny Ruby-throated Hummingbirds frequent tube-shaped flowers, such as trumpet vines. In grasslands and gardens alike, blooming milkweed draws a profusion of butterflies and moths to sip nectar. Colorful milkweed bugs also may be seen mating and laying eggs. They and their young suck sap and feed on the milkweed's seeds.

The lakeshore sees nesting Ring-billed Gulls and, more recently, Caspian Terns. A few shorebirds, such as Spotted Sandpipers and Killdeers, breed in the Chicago region. But for those that do not, it seems as soon as spring migration ends, fall migration begins. Some that breed farther north, including Semipalmated Plovers and Greater and Lesser Yellowlegs, begin traveling back south through our area as early as July, whetting appetites for yet another fall migration.

ARTIST'S NOTE: *These ducks were drawn from dioramas at the Field Museum—a great way to get close and really study your subject. Everyone is often forced to draw from photos when drawing birds (the Sandhill Crane plate on the book cover for example). But to see more, nothing can beat the actual specimen. The Blue-winged Teal requires finding the right blue and other colors closest to it on the color wheel. All browns are made by layering complements.*

PLATE XVII

Summer Marsh

Wood Duck

Order Anseriformes, family Anatidae,
Aix sponsa

(*Upper right*) Often called the most beautiful of ducks, the male Wood Duck wears a coat of many colors; the female is brownish with a white teardrop outlining her eye. Wood Ducks are resident here in the Midwest and along both coasts, but in other areas they are migrants, covering from 125 to 1,250 miles. They are one of the few ducks to nest in trees. They lay their eggs in already-formed tree cavities but will also use nest boxes. Shortly after hatching, baby Wood Ducks must leave the nest to reach food, water, and safety. Encouraged by their mother's calls, ducklings jump from the nest hole and plummet to the ground. Successful (and breathtaking) jumps of over two hundred feet have been recorded.

Blue-winged Teal

Order Anseriformes, family Anatidae,
Anas discors

(*Flying and bottom, male and female*) One of the last ducks to arrive in spring and among the earliest to leave in fall, Blue-winged Teals spend summers on our local lakes and wetlands. While some populations may be resident year-round, others migrate up to 7,000 miles between breeding areas as far north as Alaska and wintering grounds in northern South America and the southern United States. Males of this common species can be recognized by a white crescent behind the bill and white patches on the flanks. Females are duller in color with hints of white in the same places as males. In flight, notice the blue wing patch on both sexes. Blue-winged Teals are swift and aerobatic, twisting and turning in the air.

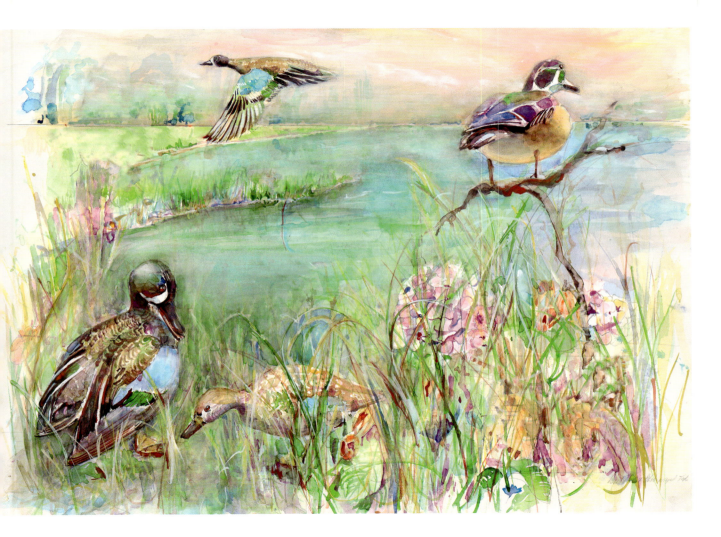

PLATE XVIII

Dragonflies

ARTIST'S NOTE: *I painted this waterfall at the Chicago Botanic Garden. Water is easier than it seems. It has a top that receives light and a side that is in shadow. Begin with moving parallel lines following the direction of the water, changing colors often because water is reflective and will bring in its surroundings. Then lay in an overwash of transparent paint to darken the side in shadow. Likewise the rocks have dimension, so don't get lost in the surface details. These colors and patterns are just like clothes. Your job is to depict form, not what it happens to be wearing.*

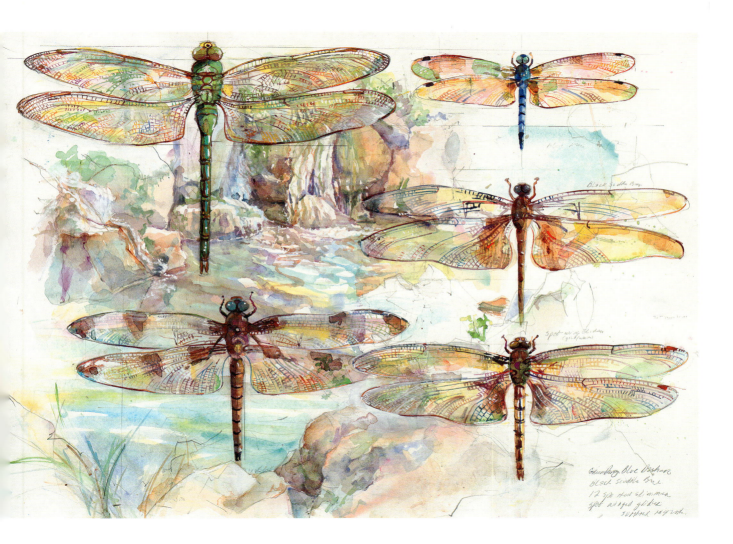

1 Common green darner

Order Odonata, family Aeshnidae, *Anax junius*

Darner dragonflies are named for their long, thin abdomens, resembling darning needles. At three inches long, green darners are one of the largest dragonflies. They're also fast, catching insects, including mosquitoes and flies, on the wing. Some green darners come to Illinois as migrants, arriving in spring. Others survive the winter as pea-green, aquatic nymphs that emerge in late spring. But by late summer, green darners can be seen migrating south, often in impressive numbers. In September 1992, an estimated four hundred thousand dragonflies flew over Cape May Point, New Jersey, in seventy-five minutes. The close-knit swarms follow "leading lines" in the landscape, such as ridges, cliffs, river valleys, the edges of lakes, and coasts. Green darner migration is one-way. Adults fly south and presumably die after laying eggs. Green darners that head north in spring are a new generation. (See also plate XXXI.)

2 Blue dasher

Order Odonata, family Libellulidae, *Pachydiplax longipennis*

A member of the skimmer family of dragonflies, blue dashers are also known as blue pirates. They are typically found at ponds, where males patrol territories and spar with other males. This small dragonfly is abundant in June, July, and August, but often present well into October. Males are blue with a black tip on the abdomen and have a white face and green eyes. Brown-eyed females are more brownish on the body with yellow lines on the upper side of the abdomen; however, they may become blue as they age. The only member of the genus *Pachydiplax* in North America, blue dashers are common throughout the United States and southern Canada in ponds, lakes, and marshes.

3 Black saddlebags

Order Odonata, family Libellulidae,
Tramea lacerata

Black saddlebags are medium-sized skimmers with bold, black saddle patterns at the base of their long hind wings. Apart from the upper Great Plains, they're present throughout most of the United States. Black saddlebags seem to be in perpetual motion, gliding and hovering up to twenty-five feet overhead and perching infrequently. Even mating is done on the wing, a spectacular feat. During fall, swarms numbering in the thousands may be seen cruising over meadows, athletic fields, and agricultural lands. Some are migratory, moving north to breed in fish-free, temporary or permanent bodies of water; the next generation flies south to flee from cold weather.

4 Spot-winged glider

Order Odonata, family Libellulidae,
Pantala hymenaea

Known for a gliding flight style, spot-winged gliders are stout-bodied, long-winged dragonflies with reddish eyes and mottled gray-brown, tapered bodies. Males have red faces, while females have yellow to orange faces. Common in the United States and southern Canada, spot-winged gliders migrate in swarms in early to mid-September. Except in the southwest, where this dragonfly lives year-round, the spring generation migrates north and the fall generation flies back south. Preferring temporary ponds and pools in the open, spot-winged gliders also can be observed flying over fields and other areas far from water.

5 Twelve-spotted skimmer

Order Odonata, family Libellulidae,
Libellula pulchella

During the summer, these medium-to large-sized skimmers can be found near almost every lake and pond in the United States and southern Canada but rarely in drier areas. Twelve-spotted skimmers have three black spots on each of their four wings, thus their name. July, August, and September make up the adult flight season, when males perch on top of wetland plants to fly "sorties." A sortie—a flight in which a dragonfly makes vertical loops around his opponent—is used to settle territorial disputes. The female makes long swoops also but does so close to the surface of the water to deposit eggs. In fall, these skimmers often become part of the gigantic dragonfly swarms migrating along the Great Lakes.

PLATE XIX

Summer Waterbirds

ARTIST'S NOTE: *To do or not to do all the feathers? In most cases the answer is to at least suggest all the feathers. There is no special award for fast in art. It is not better if it is done quickly, so relax and enjoy. I had a student who asked continually, "Do I have to draw everything?" She was exasperated at the thought. But by moving through each feather, you check and recheck your outside measurements. As you trace the contour of each feather, your line serves as a linear path, or road, from one area to the next. You are able to check distances on the specimen by moving slowly from one feather to the next. I call this part of drawing "crawling." It works like MapQuest to get you from one location to the next. Also, feathers have different jobs and therefore different shapes. I fill my brush with the appropriate paint and lay down the patch, then I clean my brush and put the tip back in the puddle. The brush acts like a vacuum and sucks up the water, leaving a distinct line and shape to the feather.*

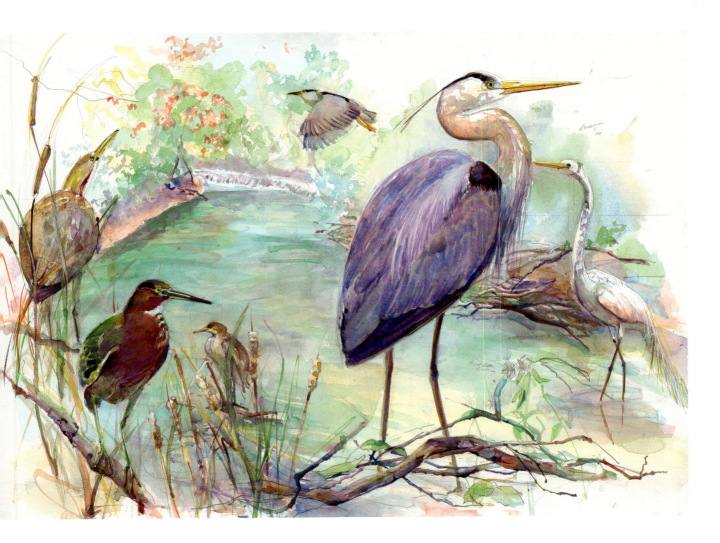

1 American Bittern

Order Ciconiiformes, family Ardeidae,
Botaurus lentiginosus

The American Bittern's *oonk-a-LUNK* call, sounding something like a toilet bowl plunger, helps locate this hard-to-spot bird in the marshes, wet meadows, and bogs where it breeds. When people get close, an American Bittern will point its bill straight up in the air. Together with its striped neck and chest, this behavior helps it blend in with tall, thin wetland plants. American Bitterns are long-distance migrants, wintering in Central America and the southern United States and breeding throughout much of the United States and Canada. In Illinois, they are now rare breeders and on the state endangered species list, probably due to the loss and alteration of local wetlands.

2 Green Heron

Order Ciconiiformes, family Ardeidae,
Butorides virescens

(*Pair*) Among the smaller herons, Green Herons have a most interesting way of catching fish—with lures. They drop twigs, feathers, and other items on the surface of the water, which attracts small prey to the spot. A Green Heron can be recognized by its small size, glossy, dark-green cap, and reddish-brown neck and head. Its yellow legs are shorter than most heron's, and its neck is often pulled in tight against its body. Green Herons summer in the eastern half of the United States and winter along the southern and Pacific coasts, down through Mexico and Central America, and into northern South America.

3 Black-crowned Night Heron

Order Ciconiiformes, family Ardeidae, *Nycticorax nycticorax*

(*Flying*) The most widespread heron in the world, the Black-crowned Night Heron ranges across North America and five other continents. However, this bird is endangered in Illinois and Indiana due to loss of the wetlands it depends upon for nesting and finding food. Some do breed here in summer, however, and more may be seen migrating along Lake Michigan. In winter, they head for warmer climates, flying only at night, often in large flocks. Black-crowned Night Herons are most active at dawn and dusk but may also forage at night, feeding in the same areas that other heron species use during the day.

4 Great Blue Heron

Order Ciconiiformes, family Ardeidae, *Ardea herodias*

One of our most common and widespread herons, a flying Great Blue with its six-foot wingspan is an impressive sight. When hunting in marshes and wetlands, their blue-gray color makes them easy to miss as they stand motionless in one spot waiting for food to swim by. In flight, Great Blues keep their long necks folded in an S shape, something that distinguishes herons and egrets from cranes that fly with necks extended. Great Blue Herons breed in freshwater and near sea coasts from Alaska south to Mexico and the West Indies. Most migrate south for winter, but a few stay surprisingly far north as long as there are nonfrozen rivers and streams where they can fish.

5 Great Egret

Order Ciconiiformes, family Ardeidae, *Ardea alba*

If you see a large white bird with a heavy yellow bill and long black legs standing in shallow water, it's most likely a Great Egret. In summer, Great Egrets can be found breeding locally, sometimes forming large "rookeries" (nurseries) in tall trees near marshes. They migrate from the Midwest, East Coast, and mountain regions of the United States down to Central and South America in winter. However, they are year-round residents along the southeastern coast of the United States and in the Caribbean.

ARTIST'S NOTE: *When I began this project, I felt that each composition should include both winter and summer habitats, but then the plates became repetitive. Soon each began to grow on its own. You have to "dance" with your painting and let it lead at times. But this plate stays with my original intention, showing the Midwest on the left and Costa Rica on the right. Because I have been to Costa Rica, I had examples of plant life and forest in my mind. Hummingbird feathers seem to change color, as their structure reflects light in different ways. Their size and quick movements make them blend effortlessly with their environments.*

PLATE XX

Ruby-throated Hummingbird

Ruby-throated Hummingbird

Order Apodiformes, family Trochilidae,
Archilochus colubris

The most widespread of all North American hummingbirds, Ruby-throats are the only hummingbird species to breed in the eastern United States. This little gem has impressive vital statistics: it's about three inches long, weighs less than a nickel, has a heartbeat of around 1,200 beats per minute, and beats its wings more than fifty times per second. Their arrival in spring is timed to coincide with the blooming of nectar-rich flowers. In fall, Ruby-throated Hummingbirds can be found migrating through urban areas, including city parks and even outside the Field Museum. They feed on tubular flowers such as bee balm and trumpet creeper and, in the process, pollinate these plants, which is an example of "mutualism," a relationship in which both members benefit. Males and females are together only for courtship and mating. Afterward, females build the walnut-sized nest and tend the young alone; males may begin to migrate as early as August. Building up large stores of fat for a marathon-like migration, many fly nonstop across the Gulf of Mexico—a distance of roughly six hundred miles—to wintering grounds in Central America.

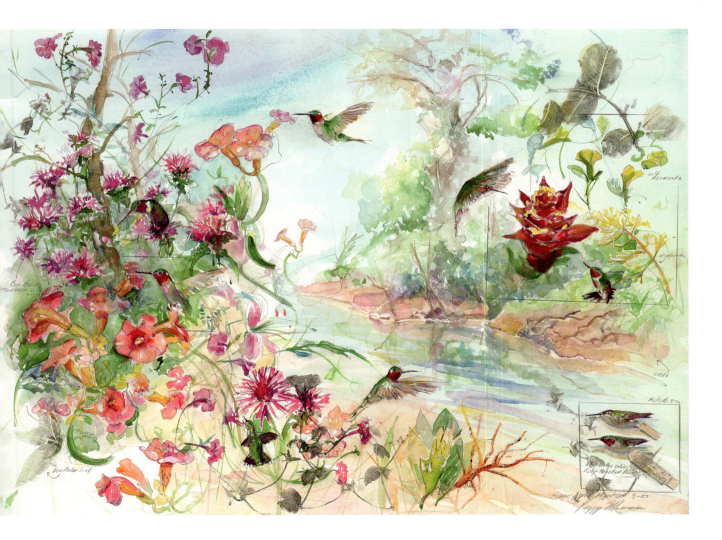

PLATE XXI

Summer Evening Insects

ARTIST'S NOTE: *Painting cicadas is a pleasure. They have clear form and pattern: the body provides sections that indicate shape and structure. Whenever there are transverse lines that describe the roundness of your subjects, consider them gifts, exaggerate them, and use them to further explain form.*

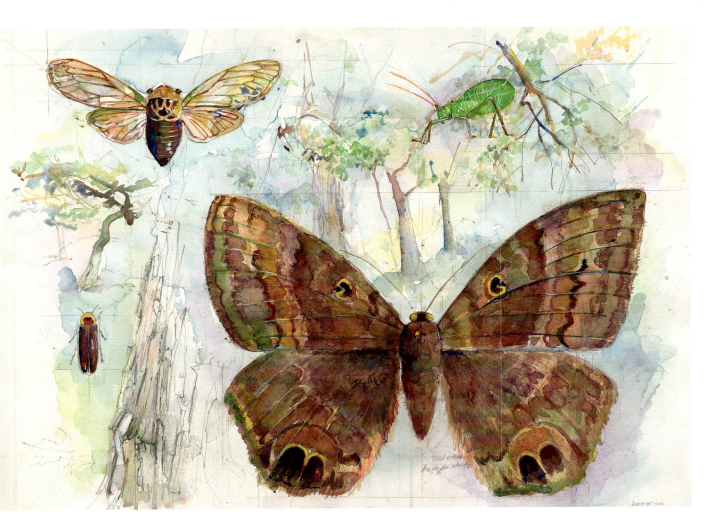

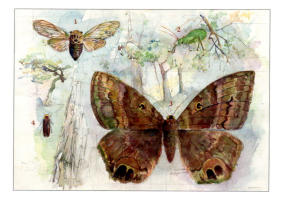

1 Dog-day cicada

Order Hemiptera, family Cicadidae,
Tibicen canicularis

This species' common name refers
to the period when it is active and
singing—the steamy dog days
of late summer. That's also the
time when the Dog Star, Sirius, is
visible in the night sky. Even the
species name, *canicularis*, means
"little dog." You can hear the
smooth whining buzz of cicadas
all day and into the early evening,
especially on very hot nights. These
annual cicadas are fairly common
throughout the eastern United
States. Nymphs develop under-
ground, feeding on roots. When
grown, the nymphs crawl out and
climb up plants or buildings. The
exoskeleton splits along the back
and the adult pulls itself out. The
distinctive calls of the males—al-
ways reminiscent of summer—are
meant to attract females. Although
the average life cycle takes three
years from egg to nymph to adult,
some adults emerge each year.

2 Common true katydid

Order Orthoptera, family Tettigoniidae,
Pterophylla camellifolia

The early evening is one of the best
times to hear singing insects be-
cause cicadas and katydids overlap
in song. Unlike grasshoppers and
crickets, both male and female
katydids make sound. Their loud
two-part *katy-DID* song is made by
rubbing their forewings together.
Usually katydids are heard but
not seen because they live in the
crowns of deciduous trees in for-
ests, woodlots, and yards. Breeding
season is in late summer and early
fall. Females will lay eggs on stems,
where they will hatch the following
spring.

3 Black witch

Order Lepidoptera, family Erebidae,
Ascalapha odorata

Perhaps because it's large, dark, and enters houses readily, the black witch moth is considered a death omen in some parts of Mexico and the Caribbean. With a six-inch wingspan, it is one of the largest moths in North America. Even the caterpillar is large, about three inches long, and strikingly colored with intricate patterns of black and greenish-brown spots and stripes. Black witches are tropical moths, resident in Mexico, Central and South America, and Texas and Florida. But they migrate north in June and are strong fliers. They have been sighted in all fifty states, including Alaska and Hawaii. Adults feed on rotting fruit and tree sap, while the larvae eat leaves from a variety of plants.

4 Common eastern firefly

Order Coleoptera, family Lampyridae,
Photinus pyralis

The gentle flashes of fireflies add a touch of magic to warm summer evenings. Each species has a distinctive pattern of flashes, which are used for finding mates. The common eastern firefly male hovers about two feet above the ground then drops. As he rises, he gives a single long flash. If a female is watching from the ground, she'll answer with her own light signal. Firefly eggs and larvae also are bioluminescent—like adults, they can produce light through a chemical process. Larvae spend winter burrowed in soil, emerging in late spring to feed. Known also as lightning bugs, fireflies are neither flies nor true bugs but rather beetles.

PLATE XXII

Sphinx Moths

ARTIST'S NOTE: *These moths are another example of the wonderful textures of insects. They have thick, round bodies, which require overwashes of transparent color. In other words, paint the whole moth, and when the body is dry, use an overwash of a transparent color, like burnt sienna, repeatedly until the body begins to have a shadowed side. Each wash should be put on a dry surface, otherwise you'll pick up the color you have previously put down.*

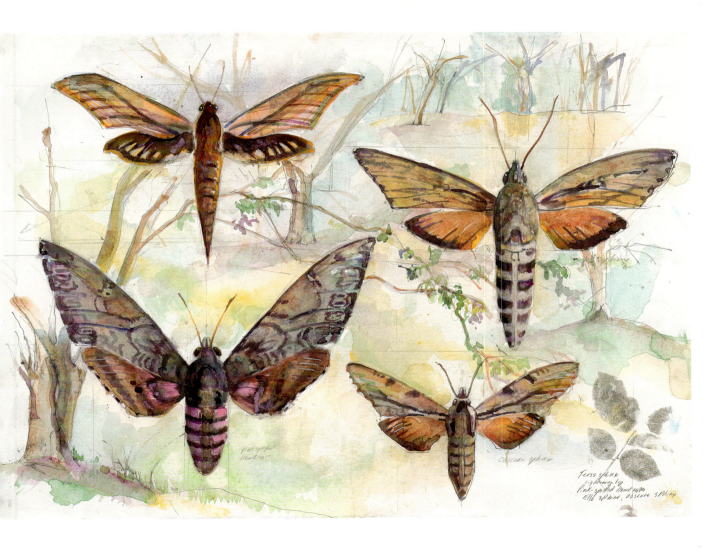

Pink-spotted
Hawkmoth

Obscure sphinx

Tersa sphinx
Lightning bug
Pink-spotted Hawkmoth
Ello sphinx, obscure sphinx

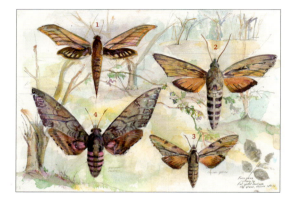

1 Tersa sphinx moth

Order Lepidoptera, family Sphingidae, *Xylophanes tersa*

With aerodynamically shaped wings and a tapered abdomen, this moth appears to be built for speed. It migrates into the region each year from the south. Adults hover like hummingbirds to feed on nectar from flowers. In the process, the flower's pollen sticks to the moth and is carried to the next plant, thereby helping the flower to reproduce. The tersa sphinx is known to pollinate the prairie white-fringed orchid (*Platanthera leucophaea*), which is endangered in Illinois and the federal government considers to be threatened. This rare plant depends on the activities of sphinx moths for its own survival.

2 Ello sphinx moth

Order Lepidoptera, family Sphingidae, *Erinnyis ello*

Distinctive gray and black bands mark the abdomen of the ello sphinx moth. Both sexes have orange hind wings with a wide black border, but the forewing patterns vary. The sphinx moth gets its name from its caterpillar. When threatened, it lifts its legs and tucks in its head, resembling that ancient Egyptian icon. Ello sphinxes are tropical and subtropical, resident from Argentina to southern Nevada. They stray north from July through October, and storms may carry them far out of their range. They've been recorded in five counties in northern Illinois. Ello sphinx adults that arrive in Illinois die when winter arrives; they don't return south.

3 Obscure sphinx moth

Order Lepidoptera, family Sphingidae, *Erinnyis obscura*

Obscure sphinx moths rarely stray into Illinois, having been recorded in just four counties. Their usual range is the northern part of South America up to the central United States. Obscure sphinxes breed continuously in the tropics, but farther north they have just a single brood from August to October. Adults feed at night on nectar. When ready to mate, a female sphinx moth attracts males by releasing a species-specific pheromone from the tip of her abdomen. Males follow this chemical plume until they locate the female to mate with her. When ready to pupate and become adults, obscure sphinx larvae spin loose cocoons in leaf litter on the ground.

4 Pink-spotted hawk moth

Order Lepidoptera, family Sphingidae, *Agrius cingulata*

Recognizable by bright pink bands on the sides of its abdomen and pink at the base of the hind wing, the pink-spotted hawk moth can be found just about everywhere in Central and South America and the Caribbean. A very strong flier, it migrates north to Canada and south to Patagonia and the Falkland Islands. Adults stray into Illinois but likely do not breed this far from their usual range. They are nocturnal, seeking nectar from deep-throated flowers, including morning glory, honeysuckle, and petunia. Larvae are known as sweet potato hornworms and feed on sweet potato leaves and jimsonweed; they're often regarded as agricultural pests in southern states.

ARTIST'S NOTE: *The white underbelly is one of the facts of animal painting that encourages the artist to go beyond what is seen. Often a specimen—bird or mammal—will appear to be white where its form would normally be in shadow if it were in the wild. It actually isn't white; it just appears so when you look at it apart from its surroundings. With the hawk on the right, only the upper portion of the breast is lit and therefore white. Take care to keep shadows in relation to each other.*

PLATE XXIII

Red-tailed Hawk

Red-tailed Hawk
Order Falconiformes, family Accipitridae,
Buteo jamaicensis

If you see a large hawk perched in the open in Illinois, it's probably a Red-tailed Hawk. One of our most common hawks, many individuals live here year-round. Red-tailed Hawks show greater color variation than any hawk species, from totally dark to fairly light colored. Typical midwestern Red-tails are brown above and whitish below with a dark belly band. Adult birds have a brick-red tail, which is fanned out in flight. Their distinctive call is a descending *keeeer*. In Red-tails and other hawks, females are larger than males. Occupying a broad range of habitats, Red-tailed Hawks are found in mixed forests, fields, woodlots, hedgerows, and roadsides. In recent years, they have also become more common in urban areas.

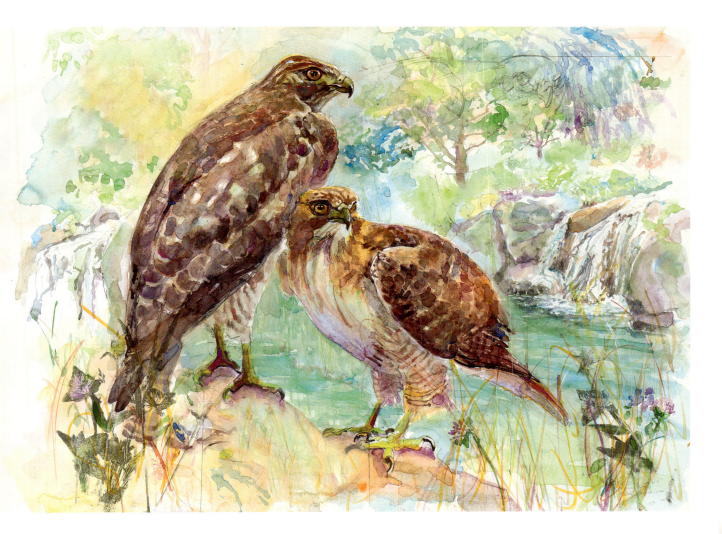

PLATE XXIV

Kathy's Field

<small>ARTIST'S NOTE</small>: *Bob Andrini is an avid birdwatcher, president of the Kane County Audubon Society, and a volunteer on Wednesdays in the Division of Birds prep lab at the Field Museum. He and his wife Kathy represent the large and growing community of birdwatchers working to protect our birds and their habitats. Bob described his wife Kathy's favorite summer scene, which became this plate.*

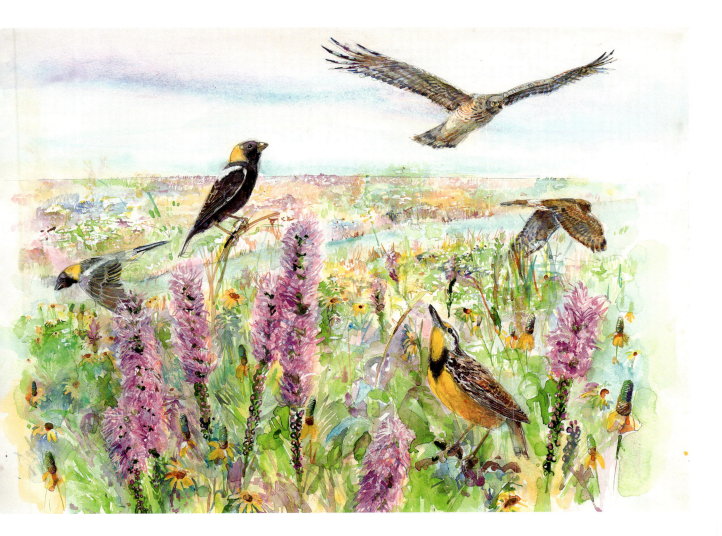

1 Northern Harrier

Order Falconiformes, family Accipitridae, *Circus cyaneus*

(*Male and female*) These hawks (formerly named Marsh Hawks) fly low and slow over fields, grasslands, and wetlands, patrolling for mice, voles, and other small mammals. Their white rumps and V-shaped wings help identify them. Males have a white belly and gray back and head, while females are mottled with browns. Northern Harriers breed in Illinois but also in a broad swath across North America. Migrants from the north pass through the Chicago region on their way to winter in the southern United States, and a few birds linger throughout the winter. In much of their range, numbers have declined due to the destruction of wetlands and prairies.

2 Eastern Meadowlark

Order Passeriformes, family Icteridae, *Sturnella magna*

With heads held back joyfully, meadowlarks send their musical whistles from fence posts across summer grasslands and fields. Their streaky backs are offset by a bright yellow throat and chest, accented with a bold, black V. Both Eastern and Western Meadowlarks can be seen in Illinois, but they're hard to tell apart visually; their songs are the best way to distinguish them. Eastern Meadowlarks breed throughout the eastern United States and into southern Canada. The northern populations, including most birds breeding around Chicago, move south in the winter. In the nonbreeding season, they form small flocks to forage in open fields. Although not currently a conservation concern, Meadowlark populations have declined significantly as a result of habitat loss.

3 Bobolink

Order Passeriformes, family Icteridae,
Dolichonyx oryzivorus

(Male, in flight and perched) You
need to visit specific grassland
habitats to see them, but Bobolinks
are well worth the trip. Breeding
male Bobolinks are the only Ameri-
can birds that are black underneath
and white on the back; they have
a distinct yellow or cream-colored
nape that they ruffle during dis-
plays. A male defends his territory
by flying around it on rapid wing-
beats. Even more remarkable is the
Bobolink's migration. From breed-
ing grounds in southern Canada
and the northern United States,
Bobolinks migrate well south of the
equator to northern Argentina and
southern Brazil—a round trip of
more than ten thousand miles.

PLATE XXV

Field and Meadow Insects

ARTIST'S NOTE: *Now we can have some fun! Insects are artists too, and they can transform their bodies or draw on themselves. I consider mimicry as a form of dressing up or tattooing oneself to appear different in the environment. For example, the buckeye has a large eye on its wing in order to appear larger than it is. The common buckeye has several examples of how to draw an eye spot. The eye spot should never be limited to a flat black spot. It should have a bit of a highlight and gradual color elsewhere. (This is also how to create a strong human eye.) Put the blackest tone around the white highlight and then graduate the value. There should be a medium tone and a light tone in addition to the highlight with black.*

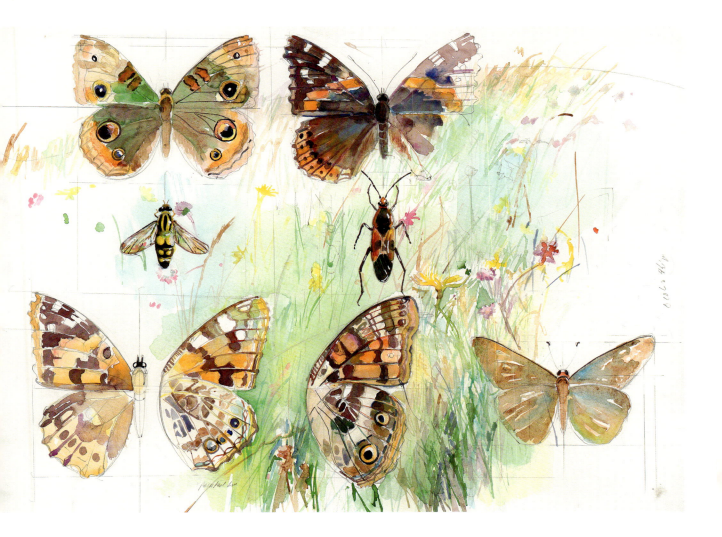

1 Common buckeye butterfly

Order Lepidoptera, family Nymphalidae, *Junonia coenia*

Buckeyes are easily recognizable by the large eye spots on their wings; when flashed suddenly, the spots distract and startle predators, such as small birds. Overwintering in the southern United States, Mexico, and the West Indies, the first brood of the year migrates north as the seasons change. Adults move into northern Illinois in April or May and breed from May to September. Buckeyes fly fast and low, just one to two feet from the ground. They feed on nectar from low-growing plants, including butterfly bush, lantana, and cosmos. Females lay eggs singly on leaf buds or the upper side of leaves of a host plant, including plantain, toadflax, snapdragon, and foxglove.

2 Red admiral

Order Lepidoptera, family Nymphalidae, *Vanessa atalanta*

Bold colors of red, black, and white may be the source of the red admiral's military name. But some believe the name derives from an earlier name—the red *admirable*. The red admiral's wings are black with white spots and red bands running across the forewings and bordering the hind wings. When its wings are closed, the undersides resemble bark, which helps camouflage the butterfly in the moist woods, yards, marshes, seeps, and fields it inhabits. Red admirals range from Guatemala north to Canada. They overwinter as pupae in southern areas, but in the north, they usually don't survive winter. Instead, migrants fly north each spring.

3 Large milkweed bug

Order Hemiptera, family Lygaeidae, *Oncopeltus fasciatus*

The conspicuous red and black of these eye-catching bugs warns predators that they're not good to eat. In fact, large milkweed bugs are poisonous. They eat milkweed plants, which ooze milky sap when the plant is wounded. This sap is a type of latex containing poisonous chemicals called alkaloids, to which large milkweed bugs have evolved immunity. Not only can the bugs eat milkweed, they also

incorporate the alkaloids into their own systems, making them too bitter for birds and other predators to eat. In northern Illinois, large milkweed bugs produce two to three generations a year. They die in freezing temperatures, so many adults migrate south in the fall. But the next summer, a new generation of adults migrates to Illinois.

4 Ocola skipper

Order Lepidoptera, family Hesperiidae, *Panoquina ocola*

Named for their quick, darting flight, skippers come and go in the blink of an eye. Skippers differ from other butterfly families in several ways. The clubs on their antennae hook backward like a crochet hook, and they have stockier bodies and larger eyes. In addition, skippers seldom fold their wings up completely; they usually keep them angled upward or spread them out while at rest. Ocola skippers live from Paraguay north to southern Texas and Florida. During summer, strays have flown as far north as Illinois. Their caterpillars feed on grasses, such as rice and sugarcane, and live in silken leaf nests that sometimes extend underground.

5 American lady

Order Lepidoptera, family Nymphalidae, *Vanessa virginiensis*

The American lady (also called American painted lady) looks similar to the painted lady illustrated to its left. But the American lady has two large eyespots on the underside of its hind wings (shown here). American ladies live year-round from Colombia and the Galapagos Islands north to the southern United States. Adults hibernate in the south, migrating to the northern United States and southern Canada in the spring. Found in open areas, roadsides, clearings, gardens, or fields with low vegetation, adults feed on nectar from many kinds of flowers. They may also get liquids from tree sap and even carrion.

6 Painted lady

Order Lepidoptera, family Nymphalidae, *Vanessa cardui*

When you see one of these butterflies in summer, you can be sure it migrated here. Painted ladies don't survive Illinois winters; they hibernate in southern states and farther south. Each year, painted ladies fly north to repopulate Illinois. Occasional population explosions in Mexico cause massive northward migrations and can make painted ladies one of the most abundant butterflies near Chicago. In other years, they may be scarce. While they don't inhabit Australia or Antarctica, painted ladies are found everywhere else, making them the most widely distributed butterfly in the world. (See also plate VI.)

7 Hover fly

Order Diptera, family Syrphidae, *Helophilus fasciatus*

Hover flies, with black and yellow stripes on both thorax (lengthwise) and abdomen (crosswise), mimic the warning colors of wasps to fool and deter predators. But hover flies are true flies, belonging to the order Diptera, meaning "two wings"; in contrast, bees and wasps have four wings. Female hover flies lay their eggs in stagnant water, and larvae develop there, breathing through a tube that extends from the abdomen. The end of this tube sticks out of the water, allowing the larva to search for food without having to return to the surface to breathe.

PLATE XXVI

Insects of Planted Fields

ARTIST'S NOTE: *Sometimes the only way to create a glistening highlight is with white gouache. The spotted cucumber beetle has a light side and a side in shadow; thin gouache is necessary to create a sufficient contrast.*

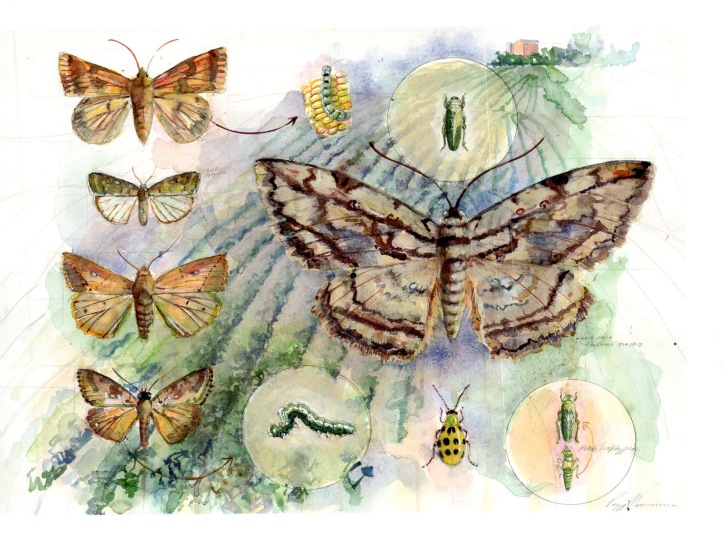

1 Corn earworm

Order Lepidoptera, family Noctuidae, *Helicoverpa zea*

(*Adult and larva*) Corn earworms are found throughout North America except for northern Canada and Alaska. They are named for their larval stage, which feeds voraciously on corn. They are also known as tomato fruitworms, sorghum headworms, vetchworms, and cotton bollworms, indicating the wide variety of other plants they also eat. Depending on the severity of the weather, their pupae can overwinter successfully as far north as Kansas, Ohio, Virginia, and southern New Jersey. However, adult corn earworm moths regularly migrate from southern states into the northern states and Canada.

2 Six-spotted leafhopper

Order Hemiptera, family Cicadellidae, *Macrosteles fascifrons*

They are tiny and cute, and spring rapidly from plant to plant. But because six-spotted leafhoppers feed on a wide range of plants—including grasses, weeds, flowers, fruits, and vegetables—they are considered garden pests. Both adults and nymphs feed by inserting their needlelike mouthparts into the plant's vascular system and sucking out the juices. In the process, they may transmit the aster yellow virus, which causes stunted growth and yellowing foliage (hence their other name, aster leafhoppers). Found from Mexico to Alaska during growing season, they inhabit grasslands, swamps, and dry prairies. While adults may overwinter in less frigid climates, others also migrate north in spring as far as 150 miles.

3 Owl moth

Order Lepidoptera, family Erebidae, *Thysania zenobia*

This is a tropical moth species typically found from Mexico down into South America. But owl moths migrate into the United States in warmer months. In the United States, it's most commonly seen in southern Texas. But while the owl moth has been recorded in many states east of the Rocky Mountains, including Illinois, sightings here are rare. The owl moth's cryptic

coloration and irregular wing margins make it appear to be a leaf or a piece of bark, allowing it to hide in plain sight. The owl moth is not considered an agricultural pest, but caterpillars will feed on various woody legumes.

4 Potato leafhopper

Order Hemiptera, family Cicadellidae, *Empoasca fabae*

(*Nymph and adult*) Potato leafhoppers can't survive frost but can live through the mild winters of Gulf Coast states. Although they can fly only short distances, they migrate north in spring, with favorable wind currents helping to carry them as far as Canada. Like other leafhoppers, potato leafhoppers feed by piercing plant tissues and sucking out juices. Their "menu" includes more than two hundred cultivated and wild plants, including fruit trees and vegetable plants such as bean, potato, eggplant, and rhubarb. Because females lay two to three eggs a day during their one-month life spans and several generations are produced each summer, they can cause significant crop damage.

5 Spotted cucumber beetle

Order Coleoptera, family Chrysomelidae, *Diabrotica undecimpunctata*

A bane to farmers and gardeners alike, the spotted cucumber beetle is found from Mexico to Canada. Adult beetles are greenish yellow with six large black spots. While most migrate northward in spring and early summer, a few may successfully overwinter, sheltering in soil under leaf litter and near buildings. The next generation migrates back south in the fall. Significant agricultural pests, adult beetles feed on and damage stems and leaves of many crops, including cucumbers, soybeans, melons, squash, cotton, and beans. In addition, they may transmit bacterial wilt and mosaic viruses while feeding. Their larvae are called southern corn rootworms, because they tunnel through the roots of young plants, stunting or killing them.

6 Soybean looper

Order Lepidoptera, family Noctuidae, *Pseudoplusia includens*

(*Larva and adult*) Soybean looper

larvae are agricultural pests, eating and skeletonizing plant leaves. Host plants include soybean, sweet potato, peanut, cotton, tomato, cruciferous vegetable, pea, and tobacco. Soybean looper moths overwinter in southern Florida and Texas, where they reproduce year-round. They're considered migratory but are aided in their northward movements by weather systems, so their summer distribution may vary from year to year. Adult female moths lay their eggs on the underside of soybean leaves. Three days later when the eggs hatch, larvae feed on the leaves. They also pupate in cocoons made from soybean leaves held together by silk produced by the larvae. Adults emerge in about a week, and in the north, only one generation is produced each year.

7 Armyworm moth

Order Lepidoptera, family Noctuidae, *Mythimna unipunctata*

Like the other moths on this plate, this species in its caterpillar (larval) stage likes the same food plants we do: corn, sorghum, and wheat, as well as a variety of vegetables. The

caterpillars crawl up the plants to feed at night, then drop to the ground and hide under debris by day. Armyworms get their name because once the larvae finish eating all the food in one field, they "march" by the thousands to a new source. Few armyworm moths survive the winter in Illinois; most migrate in from the southern states in April or May.

8 Beet armyworm moth

Order Lepidoptera, family Noctuidae, *Spodoptera exigua*

The caterpillars of this little moth are destructive agricultural pests, especially in warmer southern states. They'll devour beets, beans, broccoli, onions, peppers, and potatoes. Beet armyworm moths rarely survive winters in Illinois and other areas where frost kills its host plants. However, new adults from the southern United States will repopulate the area the following year. Native to Asia, beet armyworms are an introduced species and were first found in North America in 1876.

PLATE XXVII

American Goldfinch and Eastern Bluebird

ARTIST'S NOTE: *I did most of this painting outside at the Chicago Botanic Garden in Glencoe, Illinois. Painting outside, en plein air, requires a different set of skills than working from a photo. When outside, you have too much to include; it becomes the artist's job to choose which pieces of what lies before him or her that will best tell the story. I latch onto specifics that catch my eye and then build from there. I went to this spot because I had seen American Goldfinches playing there, and the Eastern Bluebirds just showed up. When you are sitting still while painting, you become part of the habitat.*

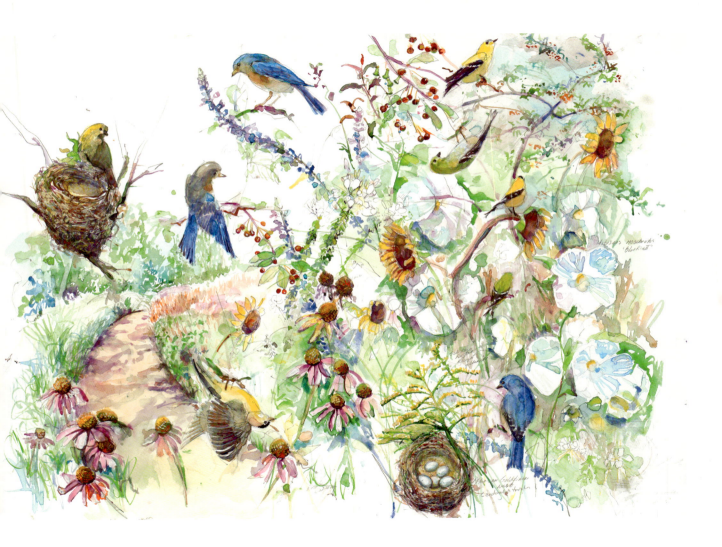

1 American Goldfinch

Order Passeriformes, family Fringillidae, *Carduelis tristis*

In spring, these active, bright yellow birds love open, weedy fields, where they cling to stems, balance on the seed heads of thistles and asters, and even hang upside down in trees and shrubs to find food. They eat primarily seeds, only occasionally swallowing an insect. As a result they are late nesters, waiting until thistles and other plants produce seeds they can feed to their young: they may be incubating eggs into late August. In breeding months, males are bright yellow with a black cap and forehead, while females are a duller yellow green. They live year around in Illinois and across the central United States, forming flocks in the nonbreeding season. (See also plate XXXIX.)

2 Eastern Bluebird

Order Passeriformes, family Turdidae, *Sialia sialis*

These eye-catching beauties have been making a comeback in the Midwest. They declined for several decades as their nest sites—tree cavities—were taken over by introduced House Sparrows and European Starlings. People have aided their recovery by putting up nest boxes, specifically sized and placed to attract Eastern Bluebirds. They are now seen fairly often perched on fences or electrical wires in meadows, open woodlands, orchards, and golf courses. From February to November, this bluebird makes its home across eastern North America from Saskatchewan to Nova Scotia and south to Texas and Nicaragua. In winter northern birds migrate to the southern parts of its range. Bluebirds sometimes stay around the Great Lakes in winter, flocking in areas where there are berries to eat.

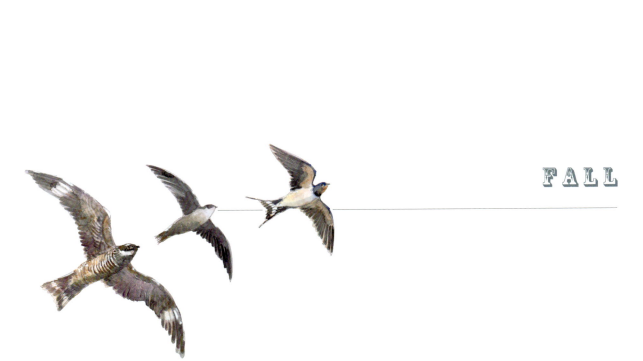

FALL

Long before there is a chill in the air, the behavior of birds and insects shows that autumn is on the way. For birds, breeding draws to a close, and adults abandon breeding territories while young get ready for their first migrations. As early as August, Red-winged Blackbirds congregate in huge flocks, moving together like one giant organism. Other species begin long-distance migratory movements. Unlike the northward push in spring, fall migration is more spread out in time and space and so somewhat less conspicuous. A challenge for fall birders is that many first-year birds don't yet look like their parents. Juvenile birds tend to be more mottled and nondescript than adults. To make matters more complex, in some species adults also molt to muted nonbreeding plumages in fall.

Reversing the pattern of spring, warblers are among the first to begin migrating. Birdwatchers consider fall warblers confusing and hard to identify, because many species sport different, less colorful plumages than in spring. In addition to warblers, also flitting about the trees gleaning insects are those little bundles of energy Ruby-crowned and Golden-crowned Kinglets. Ruby-crowned Kinglets come through earlier than Golden-crowns, continuing on to wintering areas farther south. Golden-crowned Kinglets winter farther north, including woodlots in the Chicago region.

In September and October, butterflies and other insects complete their last broods before winter. Some, like monarch butterflies, begin their own migrations south; on pleasant fall days, the skies along Chicago's lakefront may float with butterflies. Also circling overhead may be swarms of feeding dragonflies, fueling up for their flight south. But most insect species don't migrate and have to prepare to survive the coming cold. In some species, larvae make the cocoons in which they will overwinter as pupae. Adults of many species seek hiding places that provide shelter. Other species survive only as eggs—laid in soil, on plant stems, and other protected places—and await spring warmth to hatch. All hope to avoid being found and eaten by a wintering bird like a Golden-crowned Kinglet.

In October, birders flock to hills and lakes to witness the movement of thousands of migrating eagles and hawks on their way from Canada and Alaska to warmer wintering grounds. Some very rare northern species, including Goshawks and Golden Eagles, pass through during this time. The best days for viewing are when winds blow from the west, concentrating the raptors along the lakeshore. Groups of Sandhill Cranes also travel over the city in large V-formations as they ride thermals southward. During October and November, cranes stop in numbers of fifteen thousand or more at the Jasper-Pulaski Wildlife Area in Indiana, an unforgettable sight for anyone interested in the pageantry of migration.

Birds that will remain in the Midwest for winter also are hard at work. Permanent residents locate sheltered roosts and busily feed to build up fat stores. Some, such as woodpeckers, excavate tree cavities for nighttime roosts. And even as some migrants leave, others, including Dark-eyed Juncos and American Tree Sparrows, return to spend their winters here. The arrival of these species from the north is a sign that fall is again giving way to the cold and snows of winter.

PLATE XXVIII

Common Silhouettes around Chicago

ARTIST'S NOTE: *All three of these birds are present in the Chicago area between May and October, but Chimney Swifts and Barn Swallows are quite prevalent. In fact, the Barn Swallow is the most common swallow. I find multiple Barn Swallow nests under the bridges and docks on the Evanston waterfront. I learned to identify the Common Nighthawk, Chimney Swift, and Barn Swallow by their silhouettes, and once I got to know the silhouettes, I started to see them all the time. Starting in late August, these birds begin to migrate in large numbers. One September night, John Bates counted 150 Nighthawks from his backyard in Evanston. All three species migrate to South America, which is why I included the maps in this painting.*

Common Nighthawk
Chimney Swift
Barn Swallow

1 Common Nighthawk

Order Caprimulgiformes, family Caprimulgidae, *Chordeiles minor*

Common Nighthawks have one of the longest migration routes of any North American bird, wintering as far south as Argentina. They breed across North America, arriving here in May and departing by early autumn. In silhouette, the Common Nighthawk has a twenty-three-inch wingspan and long, pointed bent wings with white patches near the tips. Once called Mosquito Hawks, Common Nighthawks eat at dawn and dusk, swooping around with a distinctive bouncy flight pattern to catch flying insects. Listen for the short nasal *peent* as they fly. These birds were once fairly common in both urban and rural areas but have been waning in recent years, perhaps due to fewer available nesting sites (which included gravel roofs) and the decline of insect populations from widespread pesticide use.

2 Chimney Swift

Order Apodiformes, family Apodidae, *Chaetura pelagica*

With excellent eyesight and impressive flight skills, Chimney Swifts hunt insects on the wing. A single Chimney Swift can eat more than one thousand mosquito-sized insects each day. In silhouette, their scythe-like wings emerge from a stubby body and span about twelve and a half inches. Some scientists describe them as "cigars with wings." Chimney Swifts migrate to northwestern South America each year, but scientists still don't know exactly where they go. Even individuals tagged for research have never been seen in their wintering grounds, although they may be sighted again when they return for the summer. Chimney Swifts once built their nests in large hollow trees but have adapted to nesting in chimneys and other human-made, towerlike structures.

3 Barn Swallow

Order Passeriformes, family Hirundinidae, *Hirundo rustica*

Along with their rust and cobalt-blue coloring, Barn Swallows are easily told by their long forked tails and agile flight. They often cruise low over water or ground, doing quick turns and dives as they grab insects from the air and sometimes even dip down to take a drink. The most widely distributed swallow in North America, Barn Swallows forage in open areas, including lakes, parks, and farm fields. They gather mud and mold it into pellets to build cup-shaped nests attached to bridges, barns, or other structures. Like Cliff and Tree Swallows, Barn Swallows migrate deep into South America, following storm fronts that blow insects into the higher atmosphere.

PLATE XXIX

Fall Insects

ARTIST'S NOTE: *My friend Susan Kraut believes that we all have a specific type of composition within us and we work to refine it. When I arrange these pages, I am practicing composition. Composition, like color, has no right and wrong, so what you choose to do may be wrong for the moment but lead to something new and right. My layering system of light washes on 300 lb. paper allows me to make corrections and therefore improve a composition late in the game. I just scrub out the area that does not work, let it dry, and then begin again.*

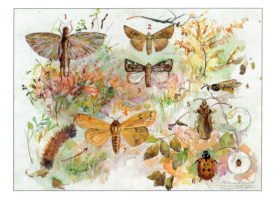

1 Migratory grasshopper

Order Orthoptera, family Acrididae, *Melanoplus sanguinipes*

True to their name, migratory grasshoppers move around, often in mass swarms. But they do so in response to food availability rather than season. By following marked individuals, scientists have found that these grasshoppers may travel thirty or more miles in a day, flying with the wind to speed their movement. They enjoy the Midwest grasslands and hold the dubious honor of being the most detrimental species of grasshopper. They have such a varied diet that they are sturdy and hard to eliminate. In addition, our farming practices, including plowing and overgrazing, create habitats that benefit these grasshoppers and allow their populations to grow.

2 Cabbage looper

Order Lepidoptera, family Noctuidae, *Trichoplusia ni*

You may know this moth best by its small, green caterpillar, which is commonly found in gardens and fields. It "loops" when it crawls, arching its back like an inchworm. The caterpillars feed on plants such as cabbage and broccoli, causing damage to these crops. After about four weeks of munching, they spin cocoons and emerge as adults roughly two weeks later. In southern states, cabbage loopers overwinter as pupae. Adult moths breed as far north as central Canada and migrate south in the fall to the southern United States.

3 Fall armyworm moth

Order Lepidoptera, family Noctuidae, *Spodoptera frugiperda*

Fall armyworm moths are native to tropical regions in Central and South America. However, the adults are strong fliers that disperse across long distances, allowing them to reach most states east of the Rocky Mountains during the summer. In the United States, they overwinter successfully only in southern Florida and Texas. Feeding primarily on grasses and grain crops, fall armyworms are considered crop pests in areas where they survive the winter.

4 Eastern yellowjacket
Order Hymenoptera, family Vespidae,
Vespula maculifrons

These familiar wasps with their yellow-and-black striped abdomens seem to be everywhere in late summer and fall, especially around food and garbage. That's because fall is a turning point for yellowjacket colonies, when workers, males and fertilized females, abandon their hives in great numbers. Only queens survive the winter, emerging in spring to start new colonies. Yellowjackets build their nests in the ground, in tree stumps, and in walls, where people can easily disturb them. Their stings can be painful and even dangerous, yet farmers appreciate them since they hunt and kill some of our most destructive crop pests.

5 Ambush bug
Order Hemiptera, family Phymatidae,
Phymata sp.

This impressive predator earns its name from its hunting technique. Sitting motionless on or near flowers, ambush bugs wait for insects to come and gather nectar and then seize them with their front legs, which resemble those of a praying mantis. Injecting poison to paralyze the prey, they devour caterpillars and other agricultural pests, as well as larger species like bumblebees and wasps. Nearly two hundred species of ambush bugs live in temperate areas of the United States and Asia. When cold months arrive, adults die, leaving their eggs unattended through the winter. Tiny nymphs emerge the following spring and immediately start preying on insects.

6 Convergent lady beetle
Order Coleoptera , family Coccinellidae,
Hippodamia convergens

This most common of lady beetles is a friend of gardeners. It eats small insects, particularly aphids and scale insects. In fact, convergent lady beetles must eat aphids in order to reproduce. A female may lay up to five hundred eggs in a few months; she will produce even more if the weather stays warm and there is a large food supply. These beetles hibernate in winter, hiding under snow or leaf litter. In western states, they converge in large masses and spend the winter under branches or rocks—or even inside homes.

7 Banded woollybear
Order Lepidoptera, family Erebidae,
Pyrrharctia isabella

(*Adult and larva*) The discovery of one of these fuzzy little caterpillars delights children and adults alike. Named for the long bristles that cover their bodies, banded woollybear caterpillars are familiar sights in autumn, when they search for shelters in which to spend the winter. Take care when handling them, because their bristles can irritate skin. The width of the black bands at each end, sometimes thought to predict the coming winter's severity, is actually an indication of how well they've been feeding on the grasses and weeds they love. Caterpillars overwinter in a dormant state, using special chemicals in their bodies to protect against freezing in the northern winters. When the weather warms in spring, the caterpillars will continue to feed and soon spin cocoons. The yellowish-orange adult moths that emerge are known by a different name: Isabella tiger moths.

PLATE XXX

City Raptors

ARTIST'S NOTE: *Jason Weckstein is an ornithologist at the Field Museum whose fourth-floor office faces Lake Michigan and includes a corner of the building. He keeps a "window count" and has seen all these birds from his window, and once he even saw a juvenile Bald Eagle carrying a fish. That is why I included the architecture in this plate. Architecture is one of the simplest subjects in art to render. Sketch the area, determine one angle through measuring, and then put your pencil across your eyes to determine your eye level. Once this line is on your paper, drag the angle to it. This is your vanishing point, and all other parallel angles will lead to it.*

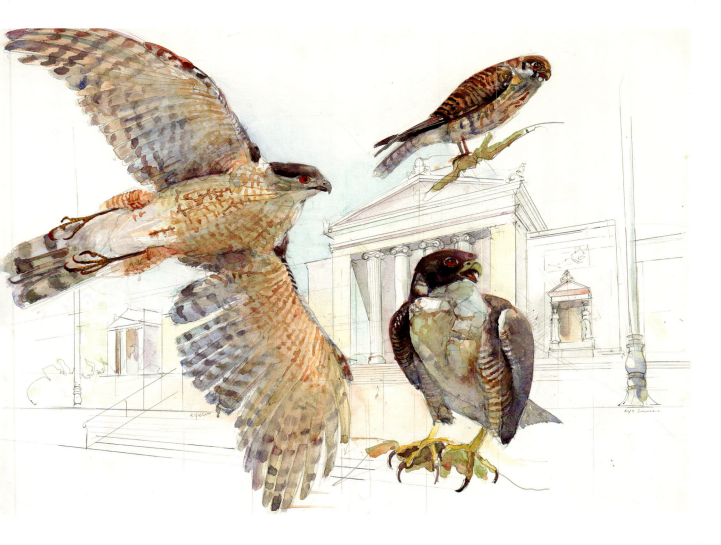

Common green darner
Order Odonata, family Aeshnidae,
Anax junius

American Kestrel
Order Falconiformes, family Falconidae,
Falco sparverius

PLATE XXXI

Timed Travelers

GREEN DARNER AND AMERICAN KESTREL

ARTIST'S NOTE: *I did a couple of drafts for this plate, including one of the specimens flying over the Field Museum campus. Jim Boone suggested that the plate focus on the swooping and diving that occurs while the Kestrel and its food supply travel. This made more sense as well as a fresh composition. A fellow artist once said to me, "Our life determines our art." In this case the subject determined my composition.*

The green darner dragonflies are among our best-known migrants. In fall, they form swarms of hundreds of thousands, which may be seen flying south over the Great Lakes, the Atlantic Coast, and other locations. Around Lake Superior, some scientists have noted that the peak of green darner migration coincides with the peak of the American Kestrel migration. These small, colorful hawks eat dragonflies, so it may be that they are following a sure food source as both species venture south. In addition, both birds and dragonflies travel on the days when winds and weather are favorable to their flight direction. (See plates XVIII and XXX for more about green darners and American Kestrels, respectively.)

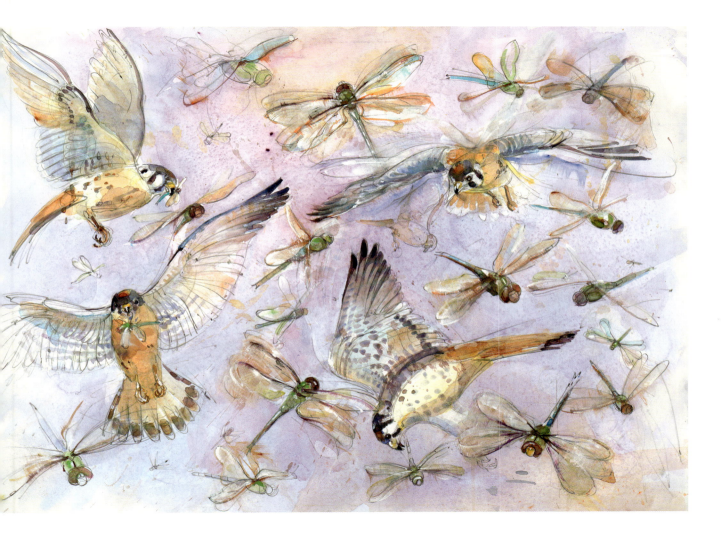

PLATE XXXII

Vireos from the Field Museum Terrace

ARTIST'S NOTE: *Bits of architecture combined with organic forms are what initially kept me drawing from the exhibits at the Field Museum. Since the classical architecture was juxtaposed with the natural history exhibits, this solved the figure-ground issue that confounds many artists. Introducing a structured element like architecture gives balance to a composition.*

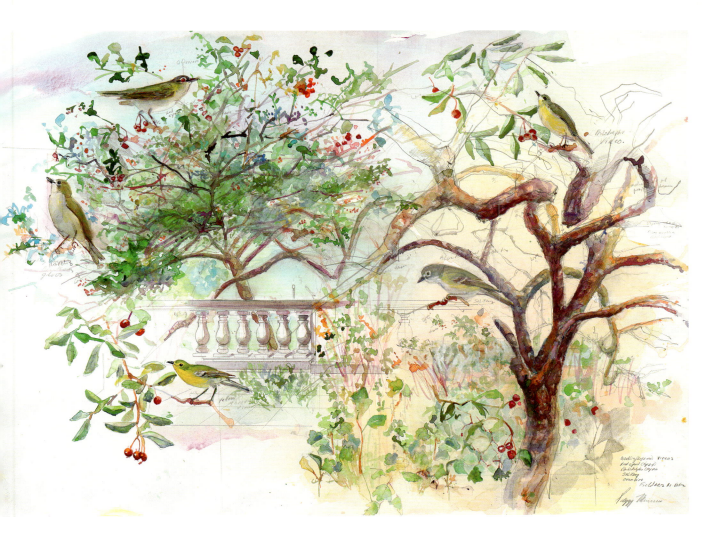

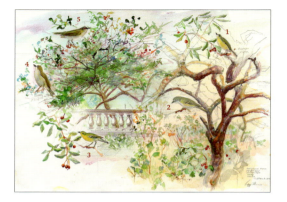

1 Philadelphia Vireo

Order Passeriformes, family Vireonidae, *Vireo philadelphicus*

Birders in the Chicago area welcome several species of vireos as they migrate during fall and spring, including the subtly-colored Philadelphia Vireo. Recognizable by a gray cap with yellowish underparts and sides, Philadelphia Vireos may feed, like chickadees, hanging upside down to pluck insects from leaves. Breeding farther north than any other vireo, they summer across Canada and in the very northern reaches of the United States. In fall, they migrate through Chicago to winter in Central America.

2 Blue-headed Vireo

Order Passeriformes, family Vireonidae, *Vireo solitarius*

Known as the Solitary Vireo until recently, the Blue-headed Vireo is now treated as a separate species due to a split of the group that also created two more western species: Plumbeous and Cassin's Vireos. Blue-headed Vireos are common vocal birds that reside in cool, northeastern forests. Although vireos can be hard to distinguish from warblers, watch for slower feeding behavior (as opposed to the fast, flitting warblers) and a thicker, slightly hooked bill. This species sports a blue-gray head and white "spectacles" around the eyes. In autumn, it can be seen heading from breeding grounds in southern Canada and the northeastern United States south to winter homes in the southeastern United States, Central America, and the West Indies.

3 Yellow-throated Vireo

Order Passeriformes, family Vireonidae, *Vireo flavifrons*

This bird's species name, *flavifrons*, means "yellow front." This plus its two-syllable *ee-aa* song helps to identify it. When pairing, a male will drop a few pieces of nest material in different locations and let the female decide where to set up housekeeping. Breeding pairs stay together only long enough to raise their young. They are quiet and solitary during fall migration, but in winter, Yellow-throated Vireos form loose groups with mixed-species foraging flocks. They winter from southern Mexico to northern South America and the Caribbean.

4 Warbling Vireo

Order Passeriformes, family Vireonidae, *Vireo gilvus*

This soft yellow-green bird lacks distinctive markings and can best be recognized by its persistent song from which it gets its name. The jumble of tones ends with a memorable high-pitched note. Males and females look alike and migrate from Alaska to Mexico and Central America. Warbling Vireos build their nests in the forked limbs of trees. These birds favor strips of deciduous forest along rivers but also golf courses and parks.

5 Red-eyed Vireo

Order Passeriformes, family Vireonidae, *Vireo olivaceus*

Although less patterned than some other vireos, Red-eyed Vireos have understated beauty, with a gray crown, dark eye line, and white eyebrow stripes framing their red eyes. In the summer, this common bird can be heard singing continually in forests throughout Canada and the eastern United States. They may call all day long—one bird was recorded singing more than twenty thousand songs in a day. Widespread throughout the United States and Canada in the breeding season, this species also has resident populations in South America, although these may be a separate species. In fall, North American populations migrate south to winter in the Amazon Basin.

ARTIST'S NOTE: *Artists have been trying to tell stories since early humans started painting in caves. The graphic novel is the newest art form integrating story with illustration. My trip to Mariposa Monarca Biosphere Reserve in Mexico would require up to five plates, so this image is an effort to combine a few views of the experience. While I show the cluster of monarchs in a northern fall forest, the circular insert in the center of the plate reveals the landscape that houses the mysterious monarch throughout the winter.*

PLATE XXXIII

Monarch Butterfly Migration in Mexico

Monarch butterfly

Order Lepidoptera, family Nymphalidae, *Danaus plexippus*

Monarch butterfly adults that emerge east of the Rocky Mountains in the fall are biologically different from their parents. They have stored fat in their abdomens to fuel migrations of more than three thousand miles to Mexico. They fly in masses to the same winter roosts used by their grandparents—fir and pine trees at elevations of ten to twelve thousand feet. In spring, monarch butterflies return to the southwestern United States. During the long flight they use the winds to carry them and often stop along their way to feed on nectar. When they find milkweed plants, they lay their eggs. Caterpillars feed on the milkweed until it is time to pupate. The butterflies that emerge continue the trip north.

Monarch populations expand and contract each year, depending on the weather at their wintering sites and the quality and availability of food. However, loss of habitat is a constant threat. To help ensure stable monarch populations in the future, use native plants in your landscapes—for example, growing milkweed as food for caterpillars and nectar-rich flowers for adults.

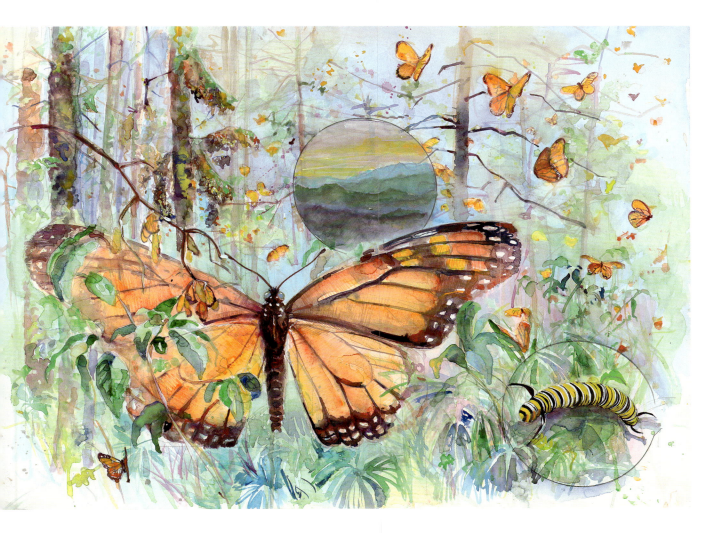

PLATE XXXIV

Fall Migrant Warblers in the Chicago Area

(SEE PLATE X FOR THE SAME WARBLERS IN SPRING PLUMAGE.)

ARTIST'S NOTE: *When painting a shoreline, make sure to make the darkest dark at the bottom of the foliage, then a white area below that and finally the reflection. Paint the reflection as you go, so greenery appears the same above and below. Lastly, make use of the transparency of watercolor. When your reflections are dry, go over the water with tree shadow or soft blues that become larger as you get away from the shore.*

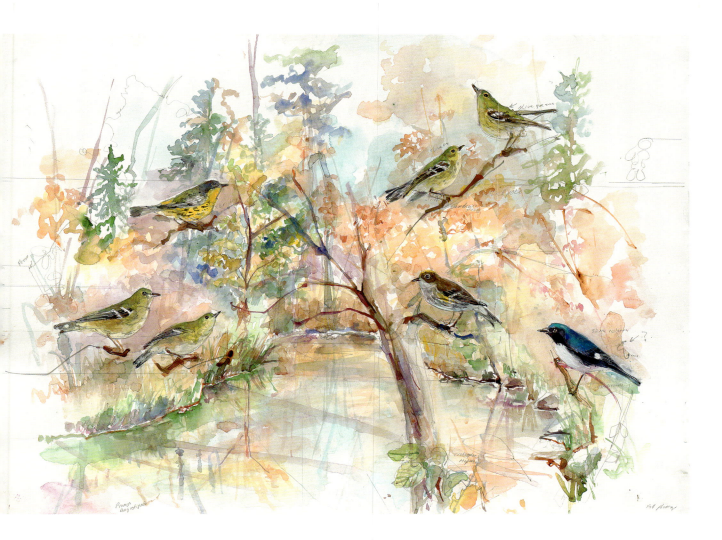

1 Blackpoll Warbler
Order Passeriformes, family Parulidae,
Setophaga striata

(*Male and female*) By fall, both males
and females have molted into
less striking plumage. Blackpolls
gather in eastern Canada and New
England, where they feast and
nearly double their weight to fuel
the journey ahead. When ready,
they take advantage of approach-
ing low-pressure systems to travel
from the East Coast far out to sea.
There, they catch northwest trade
winds that carry them south to
the West Indies or South America,
traveling nonstop 2,500 miles or
more in about four days.

2 Yellow-rumped Warbler
Order Passeriformes, family Parulidae,
Setophaga coronata

(*Male*) In fall, this bird's bright
colors fade to soft brown with
yellow patches.

3 Black-throated Blue Warbler
Order Passeriformes, family Parulidae,
Setophaga caerulescens

(*Male*) This warbler's plumage
remains the same in spring and
fall. The male's white breast sets
off its deep blue back and black
throat, while the female is a dull
olive green.

4 Bay-breasted Warbler
Order Passeriformes, family Parulidae,
Setophaga castanea

(*Male and female*) In fall, both sexes
lose the rich chestnut color of their
spring plumage.

5 Magnolia Warbler

Order Passeriformes, family Parulidae,
Setophaga magnolia

(*Male*) The Magnolia Warbler is
often referred to as the black-and-
yellow warbler. In the fall, the black
of its back changes to a soft green;
it retains the yellow breast with
streaks of black.

PLATE XXXV

October Lakefront

ARTIST'S NOTE: *The pose of the Double-crested Cormorant makes the definition of this composition instinctual for me. It presents a diagonal, which in turn encourages the opposite diagonal in the shore line. This also leaves a spot open for the Pie-billed Grebe. I'm always conscious of where the eye is going and how it travels around the page. I try to make it an easy trip.*

Double-crested Cormorant
Order Pelecaniformes, family Phalacro-
coracidae, *Phalacrocorax auritus*

(*Left*) In the past decade, Double-crested Cormorants have expanded their range northward into southern Canada and become a common breeder in the region's freshwater lakes. They leave their breeding grounds in October and head south to winter in the southern United States. During migration, large numbers can be seen moving through our area. Cormorants dive underwater to feed on fish and other aquatic animals. Lacking oil glands with which to waterproof their feathers, cormorants' wings become saturated with water, allowing them to stay underwater a long time. To fly, they must first dry their wings; that is why you will often see cormorants sitting with their wings held out. While depletions in sport fisheries are sometimes attributed to these birds, cormorants also eat alewives and other troublesome nonnative fish species.

Pied-billed Grebe
Order Podicipediformes, family Podici-
pedidae, *Podilymbus podiceps*

(*Right*) Cute, little waterbirds with chicken-like bills, Pied-billed Grebes are a threatened species in Illinois. They spend the breeding season here, building floating nests on the edges of ponds and marshes that raise and lower as water levels change. Pied-billed Grebes can compress their feathers and sink like submarines, then fluff the feathers out to rise again. When startled, they dive quickly and can stay under for up to four minutes. Found across North America in summer, their fall migration peaks in October as they head to the south-central United States and into Central America. They are rarely seen in flight as they migrate at night. They've strayed as far as Hawaii and Europe.

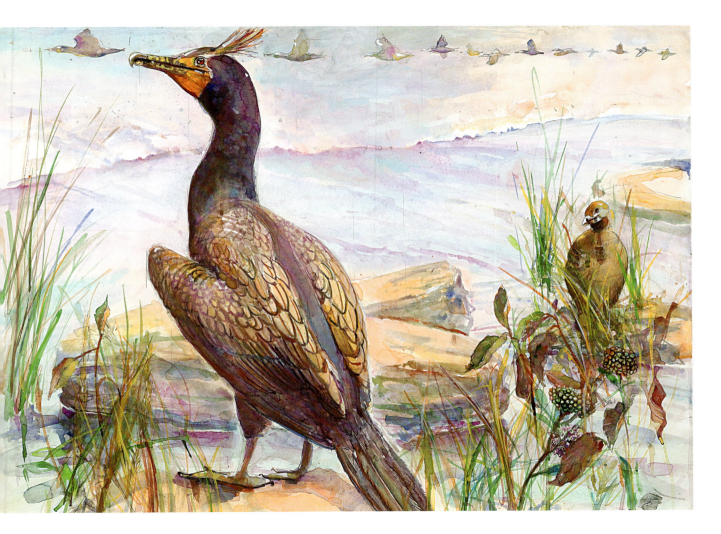

PLATE XXXVI

Kinglets

ARTIST'S NOTE: *This is another plate that I drafted three times. The kinglets kept getting lost in their habitat. Finally I added a box of specimens to show the differences between the sexes in each species. Including the kinglets' migratory route (the map and arrow) enabled me to make spaces on a map image. The House Sparrow on the lower right gives a size comparison for these tiny birds.*

Golden-crowned Kinglet
Order Passeriformes, family Regulidae,
Regulus satrapa

(*Left, male and female*) These little perpetual motion machines are among the late migrants in fall and the earliest migrants in spring. Both males and females have black stripes on their crowns and a white eyebrow stripe. But males show bright reddish orange between the black bands, while the female's crown is yellow. They breed in the spruce-fir forests of Canada. In Illinois, Golden-crowned Kinglets are seen most often during their migration to the southern United States. A few also winter in the Midwest. To survive cold temperatures, they drop their body temperatures and also roost with other kinglets to conserve heat. Look for them in flocks with other small birds, including chickadees, creepers, and nuthatches.

Ruby-crowned Kinglet
Order Passeriformes, family Regulidae,
Regulus calendula

(*Right, male and female*) Seen in Illinois only during migration, these active little birds arrive later in spring and earlier in fall than Golden-crowned Kinglets. Tiny Ruby-crowned Kinglets are usually seen flitting through the trees of deciduous forests, characteristically flicking their wings as they go. While both males and females have white wing bars and broken eye rings, the ruby crown, absent in females, is visible only when a male chooses to flash it in a display. Joining mixed flocks of small birds, most Ruby-crowned Kinglets winter farther south than Golden-crowned Kinglets, in the southern United States and northern Mexico. Although not colorful, their small size, quick movements, and "fluffball" cuteness make Ruby-crowns particularly appealing little birds.

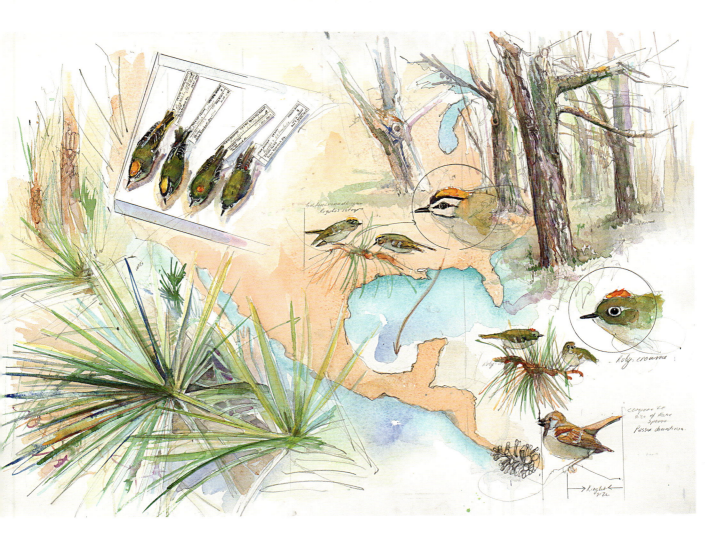

Golden-crowned kinglet
Regulus satrapa

Ruby crowned

Passer domesticus

PLATE XXXVII

Woodpeckers

ARTIST'S NOTE: *All my plates are done the old fashioned way. Occasionally I have to remove something and the computer is an easy solution, but I use it only as a last resort. I had painted a butterfly in the right-hand corner of this piece and changed my mind. Making changes works best if I scrub the area with a brush and lift off the image; a ghost of the image will remain, and this I cover with two to three layers of white gouache, sometimes tinted with slight color. Then when the area dries, I repaint.*

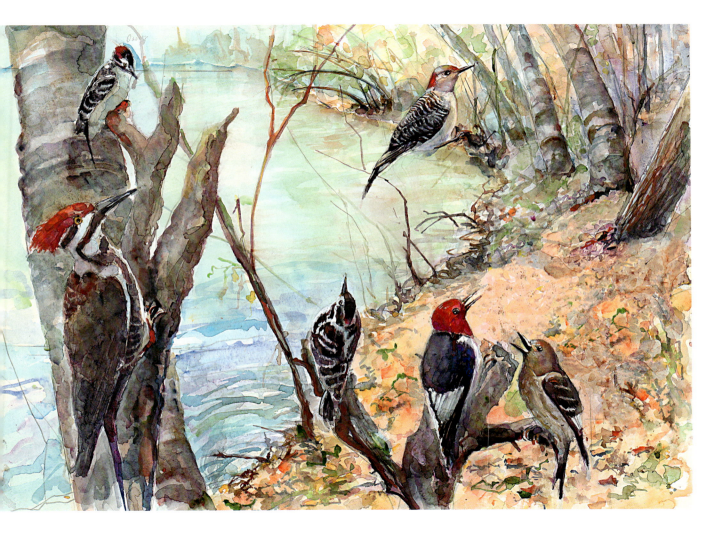

1 Red-bellied Woodpecker

Order Piciformes, family Picidae,
Melanerpes carolinus

(*Female*) This common woodpecker makes a loud, noisy *churr* sound. Despite its name, the reddish blush on its belly is usually not visible. The Red-bellied Woodpecker has a strongly barred back and red on the back and top of its head. In contrast to the female illustrated here, the male has red over the crown of its head as well. But don't mistake it for the Red-headed Woodpecker, which has a solid red head. The Red-bellied Woodpecker breeds in the summer throughout the East, from the Great Lakes to the Gulf Coast. It lives year-round in most areas, and only the northernmost populations migrate south. The Red-bellied moves from woodlands into parks in winter and frequently comes to feeders.

2 Red-headed Woodpecker

Order Piciformes, family Picidae,
Melanerpes erythrocephalus

(*Male and immature*) As fall turns to winter, the Red-headed Woodpecker stores food, hiding seeds and insects as large as grasshoppers under bark or in cracked wood. With its scarlet head, black back, and whitish wing patches, the Red-headed Woodpecker has a distinctive look both perched and in flight; the brown-headed juvenile (on the right) is just starting to get its adult feathers. Red-headed Woodpeckers eat fruits and insects in the summer, but switch to acorns in winter and may travel long distances to find them. Most local birds, along with those from farther north, migrate to the southern United States for the winter. But a few will stay if oak trees have produced a sizable acorn crop. Once very common, these woodpeckers are declining due to habitat loss.

3 Hairy Woodpecker

Order Piciformes, family Picidae,
Picoides villosus

(*Male*) A larger relative of the
Downy Woodpecker, the Hairy
Woodpecker has many similar
physical traits, including the red
spot on the back of the male's
head. However, its bill is larger in
proportion to its body than that of
the Downy Woodpecker and the
outer tail feathers lack the spots
of the Downy Woodpecker. This
nine-inch woodpecker eats many
harmful insects, such as wood-
boring beetles, and is often seen
hitching its way along trunks and
main branches. Hairy Woodpeck-
ers live from Alaska across Canada
and south to the Gulf. Most stay
in their range all year; however,
younger birds move away from
their nest sites, and adults will
move short distances when food is
in short supply.

4 Pileated Woodpecker

Order Piciformes, family Picidae,
Dryocopus pileatus

(*Female*) Resembling "Woody
Woodpecker" of cartoon fame, the
Pileated Woodpecker—at nineteen
inches long—is the largest of all
woodpeckers in our region. Whack-
ing away with its powerful bill,
sending bark and tree chips flying,
this woodpecker excavates huge
rectangular holes in dead trees in
search of carpenter ants, beetles,
and other insects to eat. The holes
are so large that other birds may
come to feed or even nest there. Pi-
leated pairs stay in their territories
all year long—the territories can be
big, around 150 to 200 acres in size.
They live year-round in forested
regions from Canada south to
northern California in the West
and the Gulf states in the East. In
fall, they'll take suet at feeders.

5 Downy Woodpecker

Order Piciformes, family Picidae,
Picoides pubescens

(*Male*) The Downy Woodpecker,
with its black-and-white checkered
appearance, is a small version of
the Hairy Woodpecker. The Downy
Woodpecker and Red-bellied
Woodpecker are the most com-
mon woodpeckers in Illinois and
frequent visitors to winter feeders,
especially for suet. The male
Downy Woodpecker has a red spot
on the back of its head; the female
does not. Downy Woodpeckers
forage actively on tree trunks, tiny
branches, or slender plant stems.
In winter, they will join with other
small woodland birds, such as
kinglets, creepers, nuthatches,
and chickadees, in mixed flocks.
The Downy Woodpecker lives
year-round across Alaska through
Canada and the United States,
except in the Southwest. It some-
times migrates short distances in
search of food.

PLATE XXXVIII

Fall and Winter Residents

ARTIST'S NOTE: *There's that shoreline again, sort of a gift. The next challenge is the black crow. It is not actually black and I never use black paint. The feather surface is reflective and, therefore, will pick up bits of its surroundings. Black can successfully be created by layering complimentary colors, such as ultra marine blue then burnt sienna, and Hooker's green and bright violet. The more layers you use, the richer the black. I try to stay true to the form by darkening the underbelly, then livening up the lit surfaces with lots of color.*

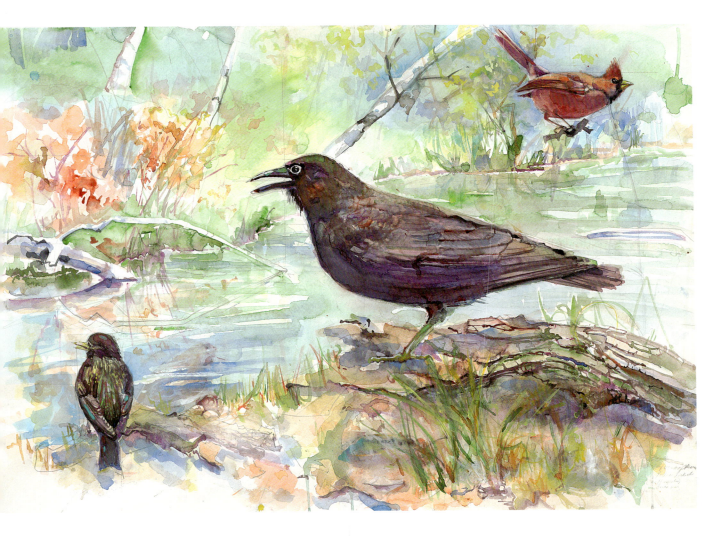

1 European Starling

Order Passeriformes, family Sturnidae, *Sturnus vulgaris*

In the fall, European Starlings gather in loud, noisy groups. Their yellow bills and iridescent feathers fade to winter colors—heavy speckles and a dark bill. These birds are native to Eurasia and North Africa. They were introduced to North America in 1890, when enthusiasts freed one hundred birds in New York City. Millions of starlings now are year-round residents in the United States and Canada, though in the East some huge flocks can be seen migrating. Starlings are strong fliers that can reach speeds up to forty-eight miles per hour. They can be messy and annoying, but they do eat a lot of insects. (See also plate IV.)

2 American Crow

Order Passeriformes, family Corvidae, *Corvus brachyrhynchos*

American Crows are widespread, loud, and very visible. Most people recognize these large black birds, which are making a comeback after being decimated by West Nile Virus a decade ago. In the fall, crows often begin gathering in huge numbers in communal roosts, where they pass winter nights until breeding season begins. They lead a complex family life. Young birds stay with their parents and help them raise offspring in succeeding years; families may contain up to fifteen individuals, including birds from five different generations. Crows breed all across North America—from Canada to Mexico—except in arid regions. Northernmost populations may migrate south for the winter, but most stay put all year around, including in Illinois.

3 Northern Cardinal

Order Passeriformes, family Cardinalidae,
Cardinalis cardinalis

(*Male*) Because we see them year-round, we may not always appreciate these beautiful birds in our midst. But Northern Cardinals are familiar to and loved by many, and seven states, including Illinois, have named them the state bird. During breeding, the flashy, red males are aggressive in defending their territories, even attacking their own reflections in windows and other shiny objects. Northern Cardinals are year-round residents in their entire range from the East Coast to the Great Plains and south into Mexico. In our region, they have been increasing in number and slowly expanding northward during the past two centuries. They eat seeds and can easily find food in areas in which people live.

ARTIST'S NOTE: *This plate is an example of how I work now. My process has grown beyond just working from museum specimens. I paint outside on location, gathering subject matter from zoos and parks as well as photos and museums. The only rule I keep is to stay with a piece. By this, I mean I try to not let more than a day lapse while working on a painting. This way I stay engaged. This does not mean that the solutions all come to me as I am working. When I can't find a way to make a painting better I let it go, only to pick it up later and, with hope, see it objectively so I can improve it.*

PLATE XXXIX

American Goldfinch in Fall

American Goldfinch

Order Passeriformes, family Fringillidae, *Carduelis tristis*

In fall, American Goldfinches lose their bright-yellow or greenish summer plumage and fade to a drab brownish yellow, retaining their distinctive black wings with bright, white wing bars. They move in small flocks, which can be located by their bubbly twittering calls. American Goldfinches are active at feeders offering thistle seed. Seen in the Midwest year-round, the individuals spotted in one season aren't necessarily the same as those in the next: American Goldfinches migrate short distances, moving in response to colder weather and decreased food supplies. (See also plate XXVII.)

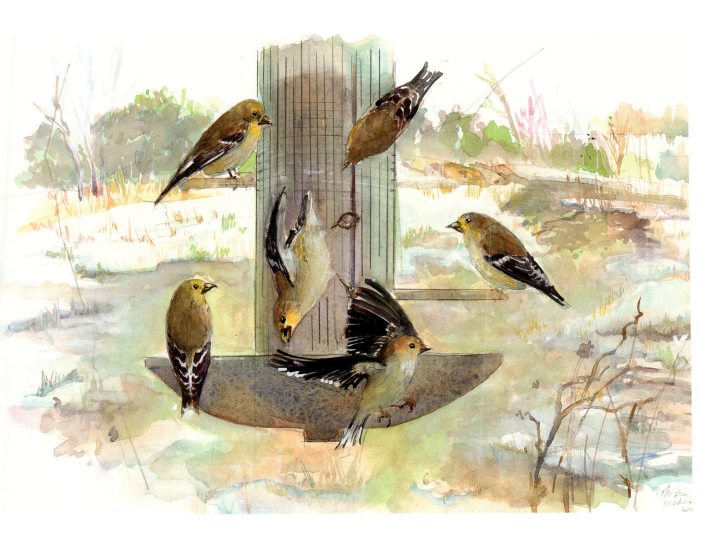

PLATE XL

Fall Game Birds

ARTIST'S NOTE: *I've always been interested in Leonardo da Vinci's study pages, in which he looks at his subject from different angles and tries to understand it better. It is under his influence that I design a page, such as this plate featuring a variety of game birds that inhabit our area year-round. The portraiture of the turkey could hold the whole page.*

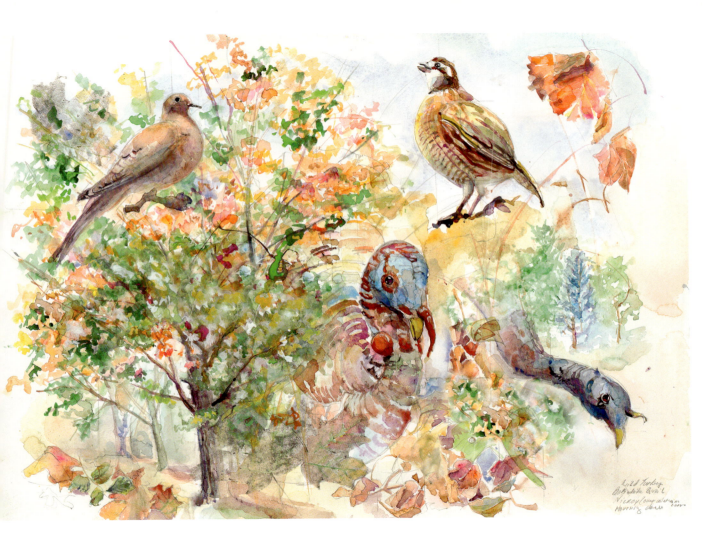

Wild Turkey
Bobwhite Quail
Nickoy Composition
Morning Dove
2001

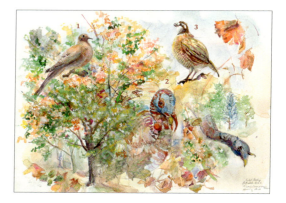

1 Mourning Dove

Order Columbiformes, family Columbidae, *Zenaida macroura*

Whether perched on a utility line or foraging for seeds on the ground, this bird can be recognized by its soft gray-brown color, relatively small head, long pointed tail, and mournful call—a soft cooing. It flies swiftly, and on takeoff, its wings make clapping sounds as they touch each other above and below its body. Despite being hunted throughout most of their range, Mourning Doves are one of the most widespread and abundant birds in North America, occupying almost every habitat, except swamps and deep forest. Their breeding range extends from southern Canada throughout the United States to Central America and the Caribbean. In winter, some individuals migrate from the northernmost regions, but many remain resident.

2 Wild Turkey

Order Galliformes, family Phasianidae, *Meleagris gallopavo*

(*Female and male*) Wild Turkeys in great numbers greeted European settlers in the East and quickly became a favored game bird, as they had been for centuries for Native Americans. Heavily hunted in succeeding decades, they were completely wiped out in the eastern United States, including Illinois. Wild Turkeys have since been reintroduced across the country and now are fairly common in every state but Alaska. The heavier male (center) has a featherless head that can be bright blue and red in breeding season; the smaller female (head shown on bottom right) has short head feathers and is generally less colorful. Both have a fleshy outgrowth on the face called a "caruncle"; its purpose is unknown. Wild Turkeys prefer to run but can also fly—they roost in trees at night. In winter, groups of a hundred birds may roost in the same cluster of trees.

3 Northern Bobwhite (or Bobwhite Quail) Order Galliformes, family Odontophoridae, *Colinus virginianus*

With a loud call, this bird announces its name—*bob-white, bob-white*. But Northern Bobwhites generally may be heard more easily than seen. The small, ten-inch, chicken-like birds stay close to the ground, hidden by taller grasses and brush; mottled brown, white, and black feathers provide perfect camouflage. They will flush into low flight if startled and are a popular game bird in fall and winter. Northern Bobwhites generally live alone or in pairs but form family groups in late summer and fall. When a "covey" of Northern Bobwhites rests at night, they will sit with their backsides pointed into a circle and their eyes facing out—better both to conserve body heat and to see approaching predators.

Trees have lost their leaves, lakes are closed with a sheet of ever-thickening ice, and abundant summer food supplies are gone. It is easy for us, tucked safe in our heated homes, to ignore the fact that outside birds and insects are struggling to survive a long, cold haul. If they have not migrated, they must either adjust or perish.

While birds generate their own heat internally, insects rely on external sources to stay warm. To survive winter, insects must be able to tolerate freezing or find surroundings that provide enough warmth to avoid it. Some produce a chemical called glycerol in their bodies to deal with winter conditions. Similar to the way that antifreeze keeps water in your car's radiator from freezing, glycerol prevents freezing of fluid in an insect's body, such as the goldenrod gall fly, springtail, and many more.

Insects overwinter in different life stages—egg, larva, nymph, pupa, or adult—depending on the species. Praying mantids overwinter as eggs, covered by

a protective substance and attached to sheltered grass stems. Some insects that winter as larvae find protection under leaf litter; other larvae burrow into soil deep enough to be insulated from the coldest temperatures. Promethea moths are an example of insects that overwinter as pupae, wrapped in cocoons attached to vegetation. Species that hibernate as adults seek shelter in tree crevices, leaf litter, spaces beneath logs and rocks, or the eaves and attics of buildings.

Some insects stay active during the winter months, such as dragonfly and mayfly nymphs. To survive, they move into the deeper water of ponds and streams, where temperatures are higher than at the frozen surface. They also rely on the ability to keep their body fluids liquid in subfreezing temperatures.

In more "citified" landscapes, feeders help sustain various bird species. Blue Jays take seeds away from feeders to cache, as do Black-capped Chickadees who dart in quickly to snatch sunflower seeds. Seed caches help birds survive periods when food is scarce. Another feeder bird, the American Goldfinch frequents thistle sacks. Although they'll also use feeders, White-breasted Nuthatches may be seen spiraling down trees, looking under bark for insects and spiders. Cooper's Hawks also patrol neighborhood bird feeders, not for seeds but for unwary birds. While we tend to sympathize with the prey, 60 percent of Cooper's Hawks perish during their first year, often due to hunting inexperience.

As harsh as winter is, birds do adapt. In open, deep water of larger lakes and rivers, Common Goldeneyes and Red-breasted Mergansers dive in search of fish, crustaceans, and other prey. Visiting Herring Gulls join resident Ring-billed Gulls in the search for food on water as well as on shore. Amazingly, January finds Great Horned Owls nesting. Young hatch in February when there's no foliage on the trees, making rabbits, squirrels, and other mammal prey highly visible to hunting parents. Fledglings leave the nest in March or April, before most other birds have even begun courting.

PLATE XLI

Winter Flock

ARTIST'S NOTE: *You cannot be a member of the watercolor society if you use white gouache to lighten an area. Now in the case of this plate I found it natural to "leave the white." But it is often the case that it works better to darken the area and then apply white gouache. Joseph Mallard William Turner (1775–1851) and many nineteenth-century watercolorists did this, so I give myself permission to break the rule. The success of the piece is the bottom line.*

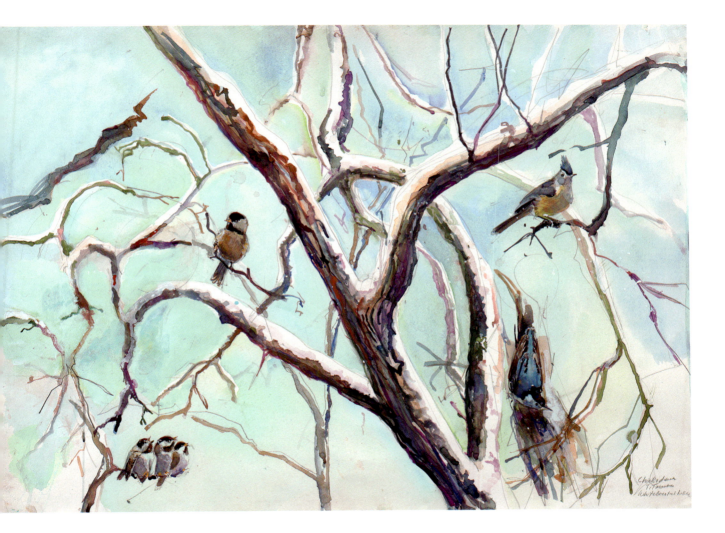

1 Tufted Titmouse

Order Passeriformes, family Paridae, *Baeolophus bicolor*

A stout, perky, little bird, the Tufted Titmouse could be called the Peterbird, since its song is a rapid *peter-peter-peter*. Tufted Titmice live around Chicago all year but are more noticeable in winter, when they leave the woods to flock with other small birds, such as chickadees, nuthatches, kinglets, creepers, and small woodpeckers. Flitting through winter branches and dropping into bird feeders, they search for seeds and nuts. Tufted Titmice will often store seeds for later eating; carrying the seeds one at a time, they shell and stash them in bark crevices. In early spring, the winter flock breaks up as pairs head for separate breeding territories. Like Northern Cardinals, this species has the Chicago region as its northern limit but appears to be slowly expanding its range northward.

2 White-breasted Nuthatch

Order Passeriformes, family Sittidae, *Sitta carolinensis*

This tiny, active bird forages with mixed flocks in winter, grabbing seeds, nuts, and suet from bird feeders. But you'll usually find it spiraling head up, head down, or sideways along tree trunks and large branches, probing for insects wintering under the bark. White-breasted Nuthatches live in Illinois year-around, their nasal *ank ank ank* revealing their presence in the canopy. The name *nuthatch* comes from the bird's practice of jamming a large nut or seed into a crack in a tree and breaking it open by hammering at it with its bill.

3 Black-capped Chickadee

Order Passeriformes, family Paridae,
Poecile atricapillus

A favorite of birders and nonbird-
ers alike, the Black-capped Chicka-
dee's familiar call says its name:
chickadee-dee-dee. The call keeps the
flock together but also acts as an
alarm. Scientists have learned that
the more *dee* notes that are sound-
ed, the greater the threat. This is
handy for warning all the birds,
including the dozen members of
its own family, in the winter mixed
flocks. Black-capped Chickadees
live year-round in woodlands and
open forest from Alaska south to
New Jersey and northern California.
They come often to feeders, but
if food becomes scarce, younger
individuals may carry out irruptive
(sudden and irregular) migration,
traveling south in huge flocks.

PLATE XLII

Sacks, Silk, and Galls

OVERWINTERING INSECTS

ARTIST'S NOTE: *When I first found boxes of insect nests in storage at the Field Museum, it was like winning the lottery. Here was endless subject matter that was not common nor had it been painted that often. A figure painter stands up against all the art that has gone before. But a nest painter has a clean slate. Nests are unexpected, as well as completely natural. The simple forms and earth tones give the artist the task of looking closely at how another artist built something. They represent nature's ingenuity, and I hope by observing them to become more adept at recognizing perfection.*

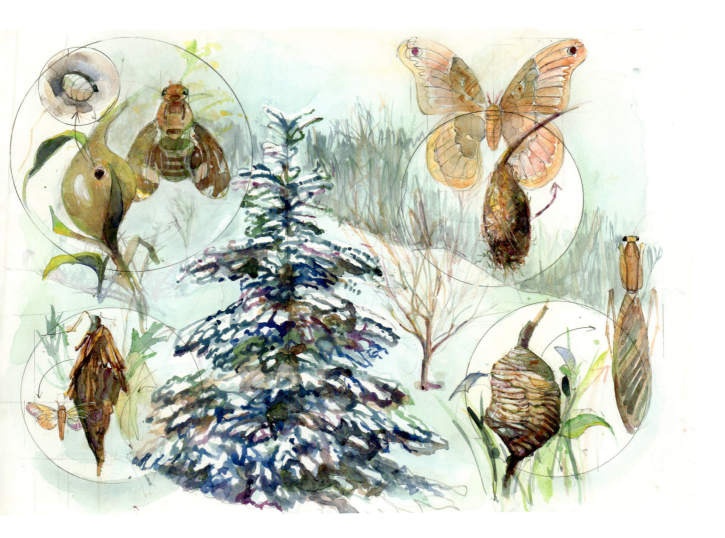

1 Goldenrod gall fly

Order Diptera, family Tephriditae, *Eurosta solidaginus*

Most of us have seen these ball-shaped swellings, or galls, on plant stems. They are often the homes of goldenrod gall fly larvae. In spring, a female gall fly lays her eggs on a goldenrod stem. The eggs hatch and as the larvae begin to eat the plant, the plant responds by creating a deformity—the gall—around the spot. The larvae live and eat inside the gall all year. In spring, the larvae pupate and become adult gall flies, which exit the gall to start the cycle again. Common on goldenrod plants, the galls don't seem to injure the plant.

2 Promethea moth

Order Lepidoptera, family Saturniidae, *Callosamia prometha*

A type of silkworm moth, the promethea overwinters as a pupa in a cocoon. A promethea larva begins in the fall by selecting a leaf from one of its favorite food trees, such as cherry, spicebush, or buttonbush. It attaches the leaf firmly to its twig with silk, then curls the leaf halfway around its body to form a cocoon. It uses more silk to wrap itself inside, sometimes covering the whole leaf. Promethea cocoons hang all winter until the adult moths emerge in spring.

3 Chinese mantid

Order Mantodea, family Mantidae,
Tenodera aridifolia sinensis

The Chinese mantid grows up
to five inches long and was
introduced near Philadelphia in
the 1800s as a biological control
against pest insects. It has since
spread throughout the Midwest.
Mantids mate in the fall. The
female lays several hundred eggs
on a twig or plant stem in a frothy
mass that is produced by glands
in her abdomen. This egg case is
called an ootheca and hardens into
a waterproof casing so tough that
an escape hatch must be included
for the nymphs when they emerge
in the spring. Mantid nymphs look
and act like tiny adults, reaching
out and grabbing insect prey with
their front legs. When hunting,
mantids assume a "praying" posi-
tion, folding the legs below their
head.

4 Evergreen bagworm

Order Lepidoptera, family Psychidae,
Thyridopteryx ephemeraeformis

Not a worm but a moth, bagworm
caterpillars build their own little,
cone-shaped homes, lined with silk
and constructed of twigs, leaves, or
other debris. Engineering marvels,
the bags are found hanging from
tree branches in the fall. Bagworms
spend their first winter as eggs
within their mother's bag. Larvae
hatch in spring, make their way
out, and start building their own
bags, eventually pupating inside
them. Most adult female bagworms
never leave their bags and do not
develop wings. A male gets out
and flies in search of a female,
fertilizing her through a tiny hole
in her bag. Once a female lays her
eggs—up to one thousand—she
finally crawls out of her bag, drops
to the ground, and dies.

PLATE XLIII

Three Chicago Owls with Blue Jays

ARTIST'S NOTE: *Owls are more common than you might think but can be hard to spot. In January 2008, a group of Long-eared Owls took up residence at a city park next to a school playground about a mile west of the Field Museum. These owls are hardly ever seen but here they were, more than ten of these magnificent birds, roosting in a set of pine trees. People came from all over to watch the beautiful creatures. These owls usually winter in rural areas or forest preserves, so why would they choose an urban park? Experts think the large adjacent lot was probably full of prey (mice and rats). So even in the city, you might get a neat surprise if you stick your head into the boughs of a pine tree to see what is there.*

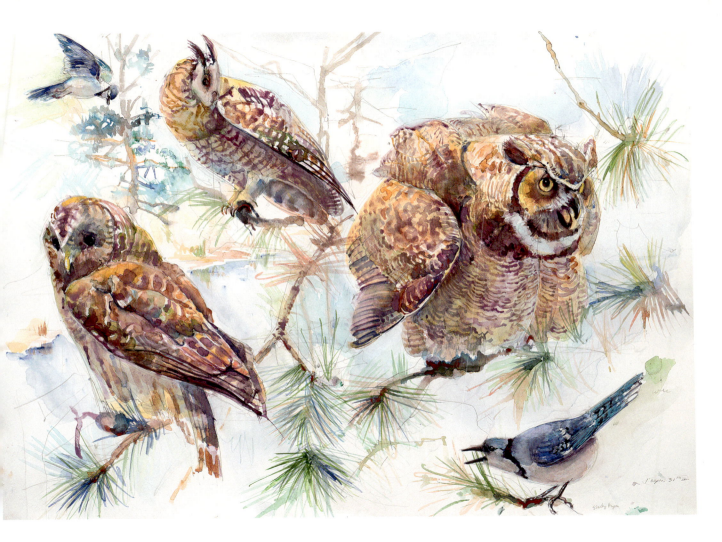

1 Great Horned Owl

Order Strigiformes, family Strigidae,
Bubo virginianus

On quiet winter nights, listen for
the resounding cry of this owl:
hoo-h'hoo hoo-hoo. Both males and
females call and the sounds can
carry for miles. (Because they are
larger birds, the female calls are
lower pitched.) Great Horned Owls
are widespread and common in
North America; our local birds
stay in their territories year-round.
They nest in winter, sitting on
the eggs in January and caring for
the young until they fledge in late
March or early April. These owls
are large and aggressive, hunting
big prey, including crows, skunks,
and even other owls. Their "horns"
are actually clumps of feathers;
they're called ear tufts though they
have nothing to do with hearing.

2 Blue Jay

Order Passiiformes, family Corvidae,
Cyanocitta cristata

Most people will recognize the Blue
Jay—one of our most feisty and
handsome resident birds. Their
loud cries of *jay jay* can be heard
ringing across neighborhoods as
they defend their nests or warn of
encroaching cats or hawks. They
lead a complex social life, and com-
municate with a wide range of calls
and by raising or lowering their
head crests. In winter, Blue Jays
often visit feeders, where they may
stuff up to five seeds at a time in
their throat pouch and hide them
for later use. Although Blue Jays
live year-round in most of their
range in southern Canada and the
eastern United States, large flocks
sometimes migrate along the Great
Lakes.

3 Short-eared Owl

Order Strigiformes, family Strigidae,
Asio flammeus

In contrast to most owls, the Short-eared Owl hunts by day as well as by night. It is also one of the most wide-ranging owls in the world, found in open grasslands across North and South America, Eurasia, and many oceanic islands, including Hawaii. In North America, it breeds across Alaska, Canada, and the northwestern states, including Illinois, moving in winter to the rest of the United States and Mexico. But their numbers in any given place can vary widely. Short-eared Owls will often move to areas that have more rodents during a given year. This owl is also one of the few species that seems to have benefited from strip-mining. It nests on reclaimed and replanted mines south of its normal breeding range.

4 Long-eared Owl

Order Strigiformes, family Strigidae,
Asio otus

Long-eared owls hunt almost entirely by sound, soaring over open areas at night and listening for the faint scratchings of mice and voles. The species is listed as endangered in Illinois, but they are easily overlooked until a winter roost, like the one described in the "artist's note," is found. One of the best ways to look for owls is to find their "calling cards" under trees. These are regurgitated pellets containing the remains of prey they could not digest. In North America, Long-eared Owls nest across Canada to the Great Lakes, Arizona, and Mexico, and many stay in their breeding areas all year-round. But far northern populations do migrate; some as far as three thousand miles.

PLATE XLIV

Snow Birds and Insects

ARTIST'S NOTE: *The winter landscape is full of color. It provides the artist with the unique opportunity to see the color of light. When you stare carefully at a shadow on the snow you are able to determine the color, which in turn tells you the color of the light—for instance, a green shadow indicates pink-orange light. Simultaneous contrast of complementary colors is most evident on a winter day.*

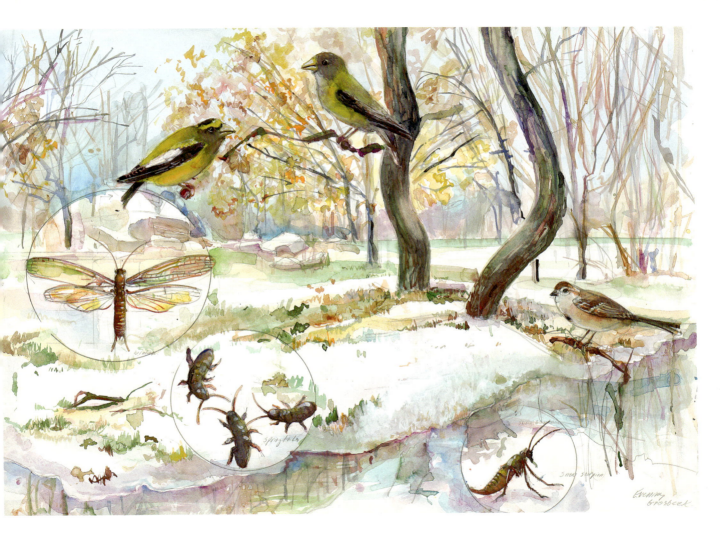

Evening
Grosbeak

1 Evening Grosbeak

Order Passeriformes, family Fringillidae, *Coccothraustes vespertinus*

(Male and female) With its yellow body and black wings, the Evening Grosbeak might at first look like a large American Goldfinch. But the Evening Grosbeak's massive bill and white wing patches are distinctive. Evening Grosbeaks appear in Illinois irregularly—mostly as winter visitors to bird feeders. Flocks of Evening Grosbeaks can clean out a feeder in an amazingly short time. Sightings of these birds here have decreased greatly over the past few years, and scientists are not sure why. Perhaps the number of seed-bearing hardwood trees has declined, or maybe the birds are not migrating as far south due to warming trends in their northern nesting areas.

2 American Tree Sparrow

Order Passeriformes, family Emberizidae, *Spizella arborea*

Despite their name, American Tree Sparrows build their nests on the ground, find food on the ground, and breed mostly above the tree line, from Alaska through Canada. They winter all across the northern United States, including around Chicago. You can pick out these bright, active sparrows near bird feeders by the rufous crown and dramatic rufous stripe leading back from the eye; they also have a black smudge on the chest. Tree Sparrows eat only insects and other animal matter in the summer; in winter, they fill up entirely on seeds and other plant foods.

3 Snow scorpionfly

Order Mecoptera, family Boreidae, *Boreus* sp.

These very small (less than a quarter of an inch long), wingless insects look a bit like fleas as they jump around on warm winter days as a way of migrating across the snow. The larvae develop underground, where they feed on mosses, and are most active in the spring and summer. The adult's long, curved "tail," resembling a scorpion's stinger, is actually the male's genitals.

4 Springtail

Order Collembola, family Hypogastruridae, *Hypogastrura nivicola*

On a warm winter day, you might see these creatures hopping about on the snow like black flecks. The tiny insects, also called snow fleas, can literally blanket a snow bank. Springtails overwinter as adults, measuring no more than one-tenth of an inch long. They generally live in leaf litter, eating decaying plants or animals. But as snow thins and melts during the day, they come out seeking food. In early spring or autumn, springtails are also known to migrate in swarms numbering in the millions, traveling about thirty feet before disappearing again into the leaf litter.

5 Winter stonefly

Order Plecoptera, family Taeniopterygidae

Look for this surprising insect on mild winter days, flying weakly or perching near water on a stone, tree, or snow bank. Adults are about a half inch long and when resting, generally fold their wings over their backs. Stonefly nymphs live entirely in water; some developing for up to four years before crawling out on a stone to form wings and become adults. Nymphs can survive only in cool, clean streams with high oxygen content; when present they indicate that a stream is fairly healthy.

PLATE XLV

Snowy Owl

ARTIST'S NOTE: *Watercolor is forgiving, contrary to common myths. There was a skull painting directly under the hawks. I removed it and covered the echo of the skull with habitat. My 300 lb. paper allows me to remove an element of the composition. I lift as much paint off as I can with water and blot, and when the surface dries, I can reapply new subject matter.*

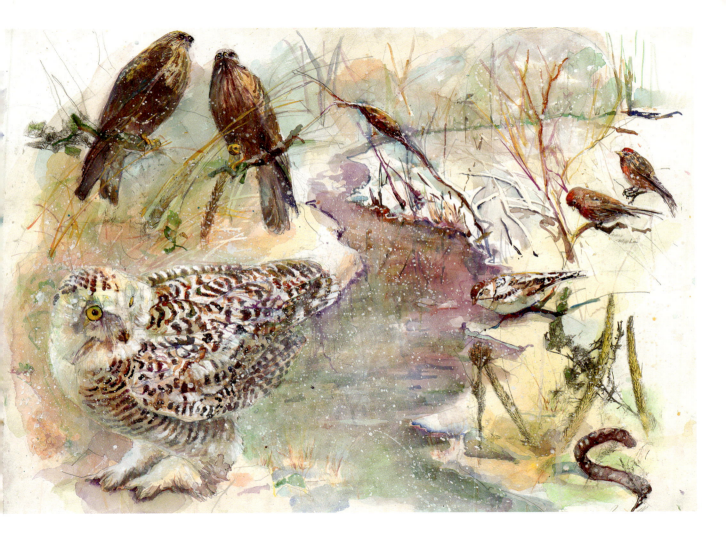

1 Rough-legged Hawk

Order Falconiiformes, family Accipitridae, *Buteo lagopus*

During December bird counts, birders hope for a glimpse of this boldly patterned raptor. Rough-legged Hawks breed in the Arctic tundra and open grasslands. By September, individuals are flying south to overwinter throughout most areas of the United States. A few pass along Chicago's lakefront, often with other hawks, especially Red-tailed Hawks. Some Rough-legged Hawks will stop here for winter if they find suitable habitat. Look for them circling and sometimes hovering over fields and open areas before dropping to seize a rodent or small bird. They get their name from being one of the few raptors whose legs are feathered all the way to their toes.

2 Purple Finch

Order Passeriformes, family Fringilidae, *Haemorhous purpureus*

A "sparrow dipped in raspberry juice" is how bird scientist and artist Roger Tory Peterson described the Purple Finch. Look for the large, sparrow-like bill and the pinkish-red head and breast of the male. Purple Finches breed in coniferous and mixed forests from Canada to the northeastern United States and Pacific Coast. In winter, they migrate south and east but in an irregular pattern that scientists don't fully understand. Some live in the Chicago area all year and will visit feeders. But Purple Finches are becoming less common in the northeast—probably being displaced by the closely related House Finch, a western bird that was introduced to the eastern United States in the 1940s and has spread rapidly.

3 Common Redpoll

Order Passeriformes, family Fringilidae, *Acanthis flammea*

Birders spot a Common Redpoll or two around Chicago most winters, but these birds tend not to stay long. At five inches long, they are slightly smaller than a Purple Finch and also have more restricted red coloring on the body. Common Redpolls are plentiful in their nesting areas "on top of the world"—in open, subarctic forests of Canada, Greenland, Scandinavia, and Russia. They eat small seeds and a few insects in summer, migrating south only in certain winters when food becomes harder to find farther north.

4 Snow Bunting

Order Passeriformes, family Eberizidae, *Plectrophenax nivalis*

Twittering flocks of Snow Buntings visit Illinois only in winter—scouring open fields, prairies, and beaches, including Lake Michigan's shoreline, for forgotten seeds or dormant insects. They breed in the far reaches of the Arctic—farther north than any other songbird. In late September, Snow Buntings head south to winter in southern Canada or the northern United States. Illustrated here is a male Snow Bunting in nonbreeding (winter) coloration: white feathers tipped with brown and brownish red and an orange-yellow bill. Breeding males are sportier, with snow white plumage, black wings with a white patch, and a black bill. Females always have more brown coloration.

5 Snowy Owl

Order Strigiformes, family Strigidae, *Bubo scandiaca*

Snowy Owls breed in the far northern tundras of both North America and Eurasia. But during some winters these magnificent owls migrate from their northern hunting areas in search of food. Some move to the Great Lakes region where they frequent larger beach areas and open fields. In early December 2011, over one hundred Snowy Owls were spotted in southern Wisconsin. They hunt by day, listening and watching for prey, such as rodents, rabbits, and other birds. Younger males and most females have significant brown feather markings like those shown here. But adult males and some females may be almost pure white.

PLATE XLVI

Winter Lakeshore

ARTIST'S NOTE: *This plate displays the glories of simultaneous contrasts and the wonders of gouache, which I sprinkled from my brush onto a dry sky.*

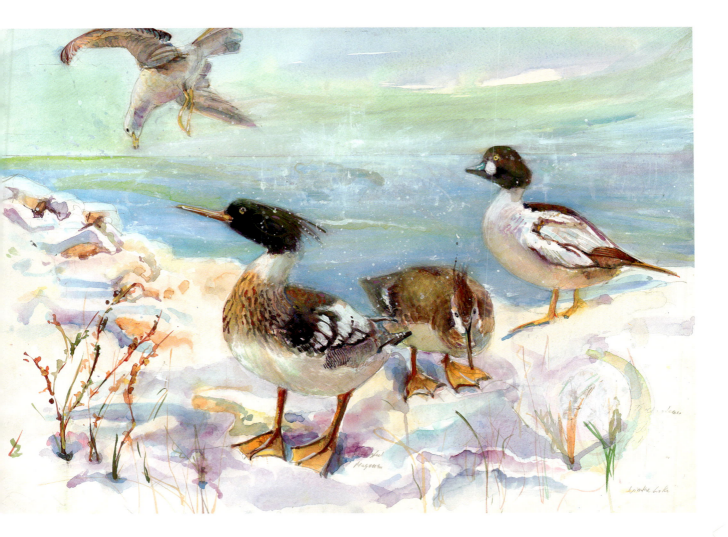

1 Herring Gull

Order Charadriiformes, family Laridae, *Larus argentatus*

The quintessential "seagull," this bird is larger than our more common Ring-billed Gull. Adults have yellow bills with a red spot. Herring Gulls breed in Alaska, Canada, and the northeastern United States, but during migration may be seen almost anywhere across the Northern Hemisphere from the tropics to the Arctic Circle. Young birds seem to make longer migrations, up to 2,500 miles. Herring Gulls are common around the Great Lakes in winter; a few even breed here. They forage along the lakefront—in the water and on beaches, mudflats, or dumps—and eat almost anything, including fish, crustaceans, earthworms, other birds, insects, and garbage.

2 Red-breasted Merganser

Order Anseriformes, family Anatidae, *Mergus serrator*

(*Male and female*) Flocks of Red-breasted Mergansers migrate along the Great Lakes. In late winter, they can be seen gathering in large groups offshore, where they dive for fish to fatten up before journeying northward to breeding sites in Canada and Alaska. The duck's dramatic profile shows a shaggy crest on the back of its head and a long, slightly hooked bill; like all mergansers, the bill has serrations that allow the bird to hold tight to slippery prey. The Red-breasted Merganser breeds farther north and winters farther south than other mergansers. In its breeding plumage, the male has a glossy, greenish-black head, a red bill, and a rusty-colored breast that gives the bird its name.

3 Common Goldeneye

Order Anseriformes, family Anatidae,
Bucephalaclangula

Its eyes are golden, but the best way to know this duck is by the white patch on its cheek. Goldeneyes are winter visitors, grouping together on open bodies of water, especially where wind and currents carry in lots of food. There they dive for fish and shellfish, including the invasive zebra and quagga mussels. Common Goldeneyes breed on northern woodland lakes and rivers and are one of the last ducks to migrate south in the fall. But by February, we can already hear the *peent-peent* of the male as he throws his head back to attract a female. Bonding early with a mate may give the birds an advantage once they return north to claim nesting areas.

PLATE XLVII

Household Insects

ARTIST'S NOTE: *I hesitated before doing this plate because most of us prefer our nature to remain outside. But insects seek shelter too, especially in winter. Jim Boone suggested basing the illustration on a house floor plan. The plate shows the insects that most likely would reside in a specific room.*

Porch

1 Eastern subterranean termite
Order Isoptera, family Rhinotermitidae, *Reticulitermes flavipes*

Termites are the result of faulty building construction—they gain access when wood touches the ground. Eastern subterranean termites nest underground and travel through tunnels to the wood above.

2 Carpenter ant
Order Hymenoptera, family Formicidae, *Camponotus pennsylvanicus*

Ants enter homes to nest and protect themselves from weather. They find openings between wood shingles or in siding, beams, joists, and fascia boards, or they tunnel their way into structural wood.

Kitchen

3 Sawtoothed grain beetle
Order Coleoptera, family Silvanidae, *Oryzaephilus surinamensis*

This beetle is so named because it has six teeth on either side of the prothorax. A larger version had to be painted because it is so small in relation to the cockroaches that you would not be able to see it. Each female produces about 370 eggs that will grow up to attack grain products. Sawtoothed grain beetles' size allows them to survive the winter hiding in cracks.

4 Indianmeal moth
Order Lepidoptera, family Pyralidae, *Plodia interpunctella*

(*Wings closed and open*) This moth was named *Indianmeal moth* because it infested cornmeal, a Native American food. But it eats any stored food, particularly dried fruit and cereal. This tiny insect can squeeze its way into plastic food storage containers, and females can lay as many as 400 eggs.

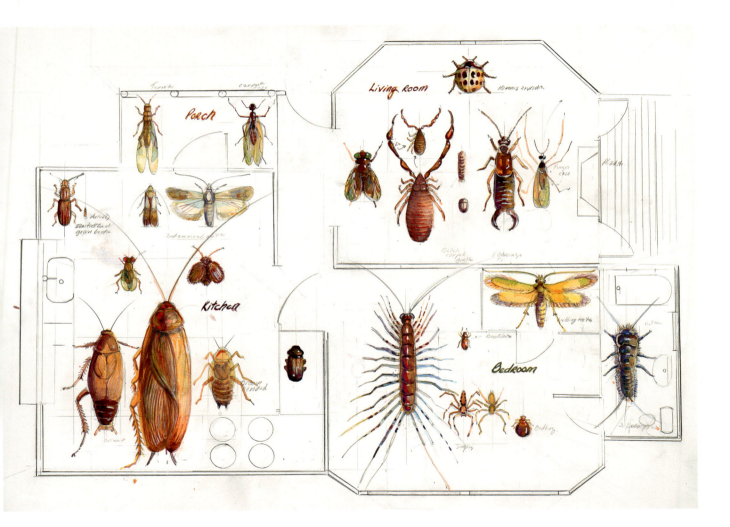

5 Fruit fly

Order Diptera, family Drosophilidae, *Drosophilia melanogaster*

The fruit fly is another familiar character with its red eyes and healthy appetite for fruit juices. Its cartoonish figure is well known because it is often used as a model of organisms described in biology. Attracted by smells of rotting fruit, fruit flies can enter homes right through ordinary screens.

6 Moth fly

Order Diptera, family Psychodidae, *Psychoda* sp.

The moth fly, although tiny, can be recognized by its hairy wings with the unusual vein pattern. It is also called the drain fly because of its preferred habitat—sink or bathtub drains.

7 Oriental cockroach

Order Orthoptera, family Blattidae, *Blatta orientalis*

Keep your basement, bathroom, and plumbing runs well caulked because any damp place will make a home for this sluggish cockroach.

8 American cockroach

Order Orthoptera, family Blattidae, *Periplaneta americana*

These are the largest cockroaches in the United States and both sexes can fly. Keep them out of your home by clearing all food sources and leaving nothing out overnight.

9 Brownbanded cockroach

Order Orthoptera, family Blattidae, *Supella longipalpa*

This cockroach is the toughest to eliminate because it requires less moisture than other species. It likes warmth and may be found in the bedroom as well as the kitchen. It seems to like electronic devices and can hide in your computers and telephones.

10 Larder beetle

Order Coleoptera, family Dermestidae, *Dermestes lardarius*

These medium-sized beetles enjoy foods with high protein content, such as pet food or dried cheese. Outside they are recyclers, disposing of animal carcasses and other waste; inside they are pests.

Living Room

11 Multi-colored Asian lady beetle
Order Coleoptera, family Coccinellidae, *Harmonia axyridis*

You might find these ladybugs moving into your home for winter. With colors ranging from pale yellow orange to bright red orange, they are at least attractive invaders. They are also beneficial—they eat aphids, mites, and other soft-bodied insects.

12 House fly
Order Diptera, family Muscidae, *Musca domestica*

Besides being bothersome, houseflies can transmit diseases from the garbage, manure, and other wastes in which they breed to the food we eat. A fly completes its life cycle in about two weeks—longer in winter. Indoors the best defense is a good offense—tight-fitting screens.

13 Pseudoscorpion
Order Pseudoscorpionidae

(*Top, nymph; bottom, adult*) These tiny spider relatives resemble scorpions in having a front pair of large, pincerlike claws. They are hard to see due to their size and tendency to hide but are not dangerous or destructive. Instead, they help eliminate pests, such as book lice, dust mites, flies, ants, and clothes moths.

14 Black carpet beetle
Order Coleoptera, family Dermestidae, *Attagenus unicolor*

(*Top, larva; bottom, adult*) Finding a single black carpet beetle does not mean you have an infestation, but they can become serious pests. If you repeatedly spot larvae and adults, find and destroy the source—often old woolen clothes and toys, bits of dried dog food, dead insects, or other materials.

15 European earwig
Order Dermaptera, family Forficulidae, *Farficula auricularia*

Despite their name (and common superstition), earwigs do not crawl into the ears of sleeping people. They *can* bite and pinch, though generally without breaking the skin. Earwigs seek out dark, moist areas, both inside and outside, where they breed and hide.

16 Fungus gnat
Order Diptera, family Mycetophilidae, Gen. sp.

Your houseplants may be growing more than just flowers. Fungus gnats are small, delicate-bodied flies that develop in the growing medium of indoor plants; there the larvae eat algae, fungi, and plant roots.

Bedroom

17 House centipede
Order Scutigeromorpha, family Scutigeridae, *Scutigera coleoptrata*

Sometimes resembling a false eyelash on the move, house centipedes can startle us as they scurry across an open floor or wall. Up to one and a half inches long with fifteen pairs of legs, they're beneficial indoors, since they eat spiders and small insects, such as silverfish.

18 Booklouse
Order Psocoptera

The tiny booklouse can barely be seen among stored books, furniture, and loose papers. Lowering the humidity in your home will limit the mold that is their main food source.

19 Webbing clothes moth
Order Lepidoptera, family Tineidae, *Tineola bisselliella*

Moth balls will deter this pest from crawling into stored clothing and laying eggs. Clothes moth larvae are so tiny they can slip through woven threads. Brushing will dislodge the eggs and larvae, or one can just keep clothes clean and expose them to daylight.

20 Jumping spider
Order Araneae, family Salticidae, Gen. sp.

Some might consider these fuzzy little spiders cute, with their quick jumping movements and prominent eyes (two eyes are larger than the other six). They hunt by day, prowling for prey and dropping a line of silk for a quick escape.

21 Yellow sac spider

Order Araneae, family Miturgidae, *Cheiracantium mildei*

This is a common indoor spider, often coming in as temperatures drop. Yellow sac spiders are active nighttime hunters who retreat by day to small silk sacs attached to door and window frames. They will bite if trapped within clothing or under sheets and are probably responsible for most spider bites in Illinois. Reactions to the bites vary but are generally not dangerous.

22 Bed bug

Order Hemiptera, family Cimicidae, *Cimex lectularius*

Bed bugs need no introduction, especially if you've ever had an invasion in your bedroom. They feed on the blood of birds and mammals, including humans, injecting saliva that causes the bites to itch or swell. In case of infestation, a good resource is http://www.entsoc.org/resources/bed-bug-resources.

Bathroom

23 Silverfish

Order Thysanura, family Lepismatidae, *Lepisma saccharina*

A common household insect, silverfish can also be found in libraries and museums. They snack on book bindings (preferring the glue and paste in the bindings as their main course) but will also get into cereals. They are hard to eliminate but easy to live with in small numbers.

STUDYING MIGRATION

There is a tremendous amount we still don't know about bird and insect migrations. Tracking a multitude of species and individuals to and from often unknown locations poses a real challenge. For example, why do species appear locally in some years and not in others? How does the population of one insect in a given year affect the migrations of the insects and birds that prey upon it? In what ways does climate change affect migrations?

At the Field Museum, more than one hundred years of collecting and monitoring birds and insects has helped provide answers as well as baseline data for the future. Procedures carried out in the Field Museum's Department of Zoology prep labs organize and record specimens and their associated data, so patterns and changes over time can be observed.

The Field Museum's thirty-year record of migratory bird casualties around Chicago holds a wealth of information. For each bird specimen brought into the Division of Birds prep lab, a variety of data, including the sex, age, and date of collection, are recorded. With

a number of specimens, this provides a picture of the migratory patterns of different age and sex classes and whether they have fluctuated. For example, we know partly through specimen records that Rusty Blackbirds are declining, although we currently don't know why. Salvaged specimens also give us tissue samples to document genetic variation; studies of feather chemistry can help us understand what habitat and latitude a bird might have bred or wintered in.

Salvaged specimens also help us understand the hazards of migration. In 1996, we collected three thousand dead birds of more than one hundred species that washed up along the shores of Lake Michigan from Oak Street Beach north to Illinois State Beach. This was a natural event that a University of Illinois graduate student was able to trace to a single storm system that crossed Lake Michigan on a May evening just as migrating birds took off over the lake.

Insect and bird scientists, along with many volunteers, regularly document and monitor local butterfly, bird, and dragonfly species, giving us a long-term

look at relative population densities in local areas over time. Understanding insect populations also provides a check on the health of local habitats and how management techniques have improved habitats to support migratory and resident animals. Through time, these yearly efforts combine to provide a broader picture of migrations through the Great Lakes region and how they may be changing.

Many eyes and ears are critical to this effort. You can partner with the Field Museum and other organizations to study migration by contacting one of the following groups:

+ eBird *http://ebird.org/content/ebird/*
+ Bird Conservation Network *www.bcnbirds.org*
+ Birding on the Net (Illinois) *http://birdingonthe.net /mailinglists/IBET.html*
+ Illinois Dragonfly Monitoring Network *http://www .anisoptera.org/aboutus.html*

PLATE XLVIII

Nine Days in May

ARTIST'S NOTE: *For the past five years I have been collecting specimens that hit windows on the Northwestern University campus during the spring and fall migration periods. This plate shows the birds I collected May 8–16, 2009. I walked through the campus at about 6:00 a.m., circling all of the buildings where the glass windows might interfere with birds migrating. There are five- to six-story buildings farther west, but these seem less dangerous to the flyers than the two- to three-story buildings that face the lake.*

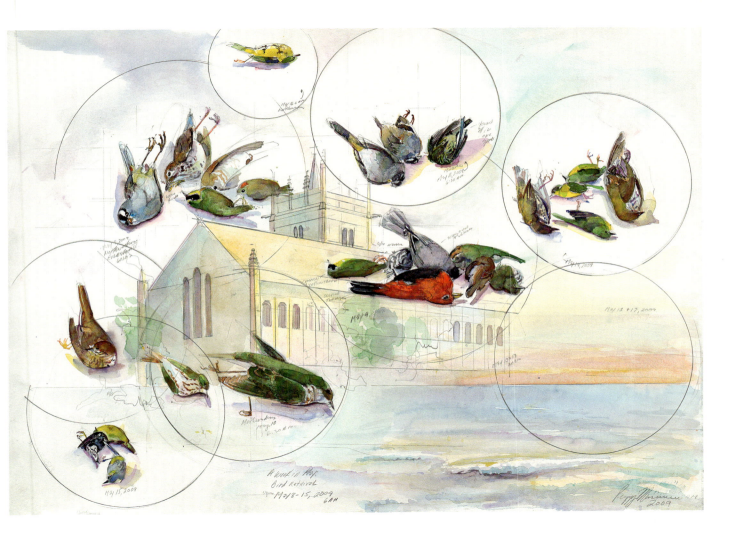

PLATE XLIX

Scenes from the Division of Birds Prep Lab, Field Museum

Dave Willard (left) sits at the counter adding specimens' details into his thirty-year journal. Tom Gnoske (center) is one of the few remaining taxidermists at the museum. He accompanies scientists to sites all over the world to prepare birds. Mary Hennen (right) manages the bird collection.

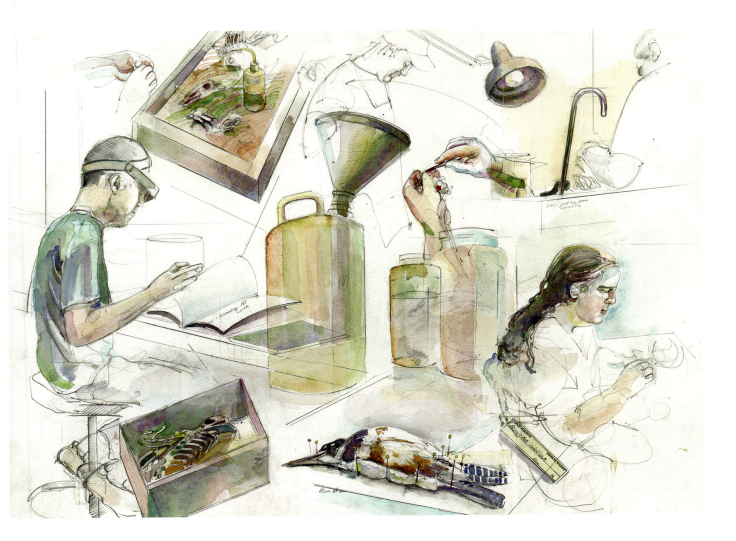

PLATE L

Preparing a Bird Study Skin

ARTIST'S NOTE: *To draw hands, it helps to squint and simplify forms. Keep in mind that you are drawing shapes (not hands). Begin with a rough gesture of the shapes and refine through crawling (see plates XVI and XIX) and measuring. People often think that drawing fingers in detail will convince the viewer. But the fact is that it is the darks and lights on the forms will create hands.*

SEQUENCE OF ARROWS FROM UPPER LEFT:

+ American Woodcocks are birds commonly found as window casualties along the lakefront.
+ After recording external data from the specimen, the preparator gently severs the skin the length of the bird's abdomen, being careful not to cut into the body cavity.
+ By working fingers carefully under the skin, the preparator separates it from the muscles and other body tissue, leaving behind the skull, wings, and legs.
+ The bird's body is carefully removed from inside the skin and the brain is washed from inside the skull.
+ The body cavity is then stuffed with cotton in the appropriate size and shape.
+ The preparator then "pins" the bird, arranging it on its back in such a way that it can be easily stored and studied. After a few weeks airing in this position, the skin becomes dry, fairly stiff, and well preserved without decay for many decades.

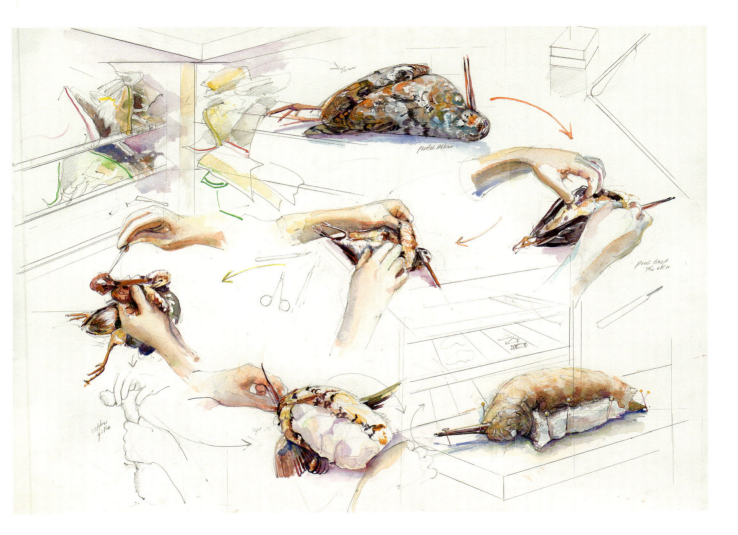

ARTIST'S NOTE: *Portraiture is best done by beginning with the in-between areas rather than the features. Draw the shapes around the eyes rather than the pupil and eyelid. Likewise concentrate on the areas above and below the nose. This will help you not fall into the trap of misjudging the lengths between the eye, nose, and mouth. Lips are often best described by the shadow below the lower lip.*

PLATE LI

Monitoring Butterflies on Northerly Island

All over Illinois, people are managing prairie and woodland sites. Most of the management activities have involved plants. In 1987, the Nature Conservancy decided to explore the effects of management on animals by creating the Butterfly Monitoring Network (BMN). Dr. Doug Taron, curator of biology at the Chicago Academy of Sciences' Notebaert Nature Museum,

collaborated with this effort to explore the effects that habitat management has on butterfly populations. He founded the Illinois Butterfly Monitoring Network (IBMN) in 1995 and began monitoring at seven sites in the Chicagoland area. Since then, people have been monitoring the health of butterfly populations throughout northeastern and central Illinois. These citizen-scientist volunteers come from all walks of life to help in this ongoing program. A few people come to the program already knowing many butterflies, but most people begin knowing just a few common species. More than two hundred sites are now being monitored every year, and the program is being expanded throughout Illinois. Through analysis of the extensive database, population trends of species throughout

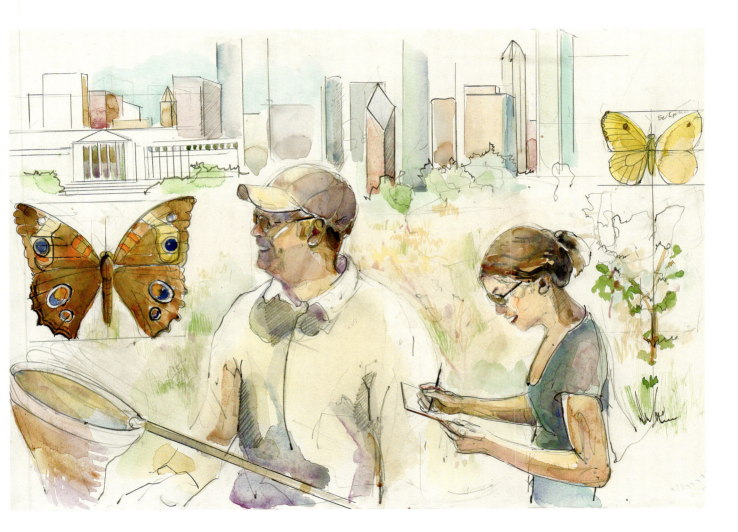

the Chicagoland area are starting to emerge. These results will assist land managers in more effective conservation of the state's butterflies.

Northerly Island is a ninety-one-acre peninsula located on Museum Campus. The majority of the space on Northerly Island is dedicated to nature and has been designated as a bird and butterfly sanctuary. It has a great variety of native plants that provide food and shelter for many animals, including mammals, butterflies, and birds. Jim Boone and Lisa Hung observe, identify, and count butterflies once a week through the summer months. Common butterflies that are seen include buckeyes, monarchs, sulphurs, and swallowtails.

The Chicago Park District is in the process of transforming Northerly Island to include more active attractions in the north half of the park, such as larger summer concerts in the amphitheater and other events in the pavilion, as well as retail space and outdoor exhibits. Wetlands and a marsh will be installed in the southern half of the park to allow for passive activities such as birdwatching. The plans also include an outdoor classroom, informal paths, a fishing pier, and a camping area. In addition to the wetlands and marsh, the park will be landscaped with woodland, savannah, and prairie plants, and the different areas will be connected by boardwalks, foot bridges, and various trails. These changes are scheduled to be completed over the next twenty to thirty years.

CONCLUSION

Doug Stotz is a conservation ecologist with the Field Museum. His research provides us with some closing thoughts on the future of migration. Doug and his colleagues are concerned with habitat loss, climate change, and other issues that affect the future of birds and migration.

One of the biggest problems for migrating birds is habitat loss—on their breeding and wintering grounds, as well as along their migratory routes. Protecting and restoring natural areas and maintaining green space in urban areas remain important to migratory birds. The canopy of trees in city parks, cemeteries, and residential areas provides resting spots for the weary travelers. Restored patches of wetlands and prairies provide habitats that support insects and also provide food for birds. Maintenance of agricultural lands is also important. Shorebirds use flooded farm fields in spring for their migratory stopovers.

Another problem is mortality due to collisions with buildings. Birds are attracted to lights, especially red and white lights. This may be because they use the stars and moon to find their way. Hundreds of millions of birds, mostly songbirds, are killed every year by flying into buildings. Much has been done in Chicago to reduce this mortality rate. Collaborations between scientists, local bird enthusiasts, building managers, and the city of Chicago have resulted in many lights being turned out in tall buildings during migration, reducing bird mortality by 80 percent. A "bird safe" glass also has been developed but is still too expensive for wide use.

Climate change is probably the most important issue affecting bird migration. Birds have complicated life cycles, opening many opportunities where climate change will have an effect. Most birds use day length to time their migrations. But plants and insects often respond to current weather, potentially creating a timing mismatch between migrating birds and the resources on which they rely.

A very real local example concerns the correspondence between the spring peak of migration by insectivorous birds and the timing of oak tree flowering and leafing-out. With changing climate, leaf-out is taking place an average of four to five days earlier per degree of increase in temperature. Because a large number of bird species use oaks for foraging,

Doug asks the question, what would happen if the timing of the oak leaf-out and peak migration no longer corresponded? Oak-using migrants that might be affected include Blue-gray Gnatcatchers, Rose-breasted Grosbeaks, Tennessee Warblers, Blackburnian Warblers, and Bay-breasted Warblers. Oaks, too, could be impacted by a shortage of insect eaters during leaf-out. Although the consequences for both birds and trees are unclear, the conditions to create timing mismatches between migrants and the resources on which they rely are increasing worldwide.

Birds continue to migrate and other seasonal strategies still play out. But change is evident. What will happen as human activity changes the seasons themselves?

WATCHING BIRDS AND INSECTS IN CHICAGO

Popular birding sites in Chicago include the Magic Hedge of Montrose Harbor, the Bird Sanctuary in Lincoln Park, and Wooded Isle in Jackson Park.

Places to find insects include any area that is mainly left undisturbed or any area cultivated to attract wildlife. In Chicago these areas include North Park Nature Center, Northerly Island, the Magic Hedge, Montrose Harbor/Beach, the nature area around Peggy Notebaert Nature Museum, most of the large city parks, some of the older and larger cemeteries, and the dunes near Rainbow Beach.

FURTHER READING

BIRDS

Carpenter, Lynne, and Joel Greenberg. *A Birder's Guide to the Chicago Region*. DeKalb: Northern Illinois University Press, 1999.

DeVore, Sheryl. *Birding Illinois*. Helena, MT: Falcon Press, 2000.

INSECTS

Bouseman, John K., and James Gordon Sternburg. *Field Guide to Butterflies of Illinois*. Champaign: Illinois Natural History Survey, 2001.

Butterflies and Moths of North America. http://www.butterfliesandmoths.org.

Rosche, Larry O., Linda K. Gilbert, and Judy M. Semroc. *Dragonflies and Damselflies of Northeast Ohio*. Cleveland, OH: Cleveland Museum of Natural History, 2008.

Stokes, Donald W. *A Guide to Observing Insect Lives*. Boston: Little, Brown, 1983.

CONTRIBUTOR BIOGRAPHIES

PEGGY MACNAMARA, *adjunct associate professor, School of the Art Institute of Chicago; artist-in residence and associate of the Zoology Department, Field Museum* ⋆ Peggy has a master's degree from the University of Chicago in art history. She is the author of *Painting Wildlife in Watercolor, Illinois Insects and Spiders*, and *Architecture by Birds and Insects*.

JOHN BATES, *associate curator, Division of Birds, Field Museum* ⋆ "Called" by birds at a young age, John received his PhD in 1993. He has been with the Field Museum since 1995. His research focuses on genetic structure in tropical birds, primarily in South America and Africa, and its implications for evolution and conservation. He also trains and mentors students from tropical regions for biodiversity research in their countries.

JAMES H. BOONE, *collection manager, Division of Insects, Field Museum* ⋆
James has been at the Field Museum since 2002 and became collection
manager of insects in 2011. He has a master's degree in entomology and
fourteen years' experience in entomological labs and museums at Penn
State and the University of Vermont prior to joining the Field Museum.
He is a member of the Illinois Butterfly Monitoring Network and moni-
tors butterflies around Chicago.

FINAL ARTIST'S NOTE: *Birds and insects have truths to teach the artist. Observing and rendering the attributes of specimens helps enrich the artistic sensibility. While painting this Snowy Owl, I was delighted to discover that the pattern on the wings was the exact image of cranes migrating. It was as if the owl had anticipated its place in the migration story and illustrated cranes in flight to contribute.*

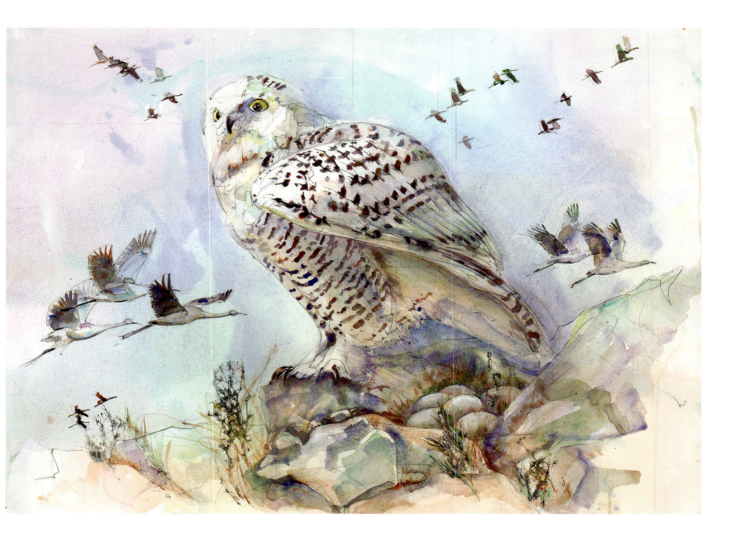